D0071222

Writing About
ART

Writing About
ART

ELIZABETH ADAN
(California Polytechnic State University,
San Luis Obispo)

KAREN M. GOCSIK
(University of California, San Diego)

Writing About Art © 2019 Thames & Hudson Ltd, London

Text © 2019 Elizabeth Adan and Karen M. Gocsik

Published by arrangement with W. W. Norton & Company, Inc.

Typeset by Mark Bracey

All Rights Reserved. No part of this publication may be reproduced or transmitted in any form or by any means, electronic or mechanical, including photocopy, recording or any other information storage and retrieval system, without prior permission in writing from the publisher.

First published in the United States of America in 2019 by Thames & Hudson Inc., 500 Fifth Avenue, New York, New York 10110

www.thamesandhudsonusa.com

Library of Congress Control Number 2019940760

ISBN 978-0-500-841815

Printed and bound in China by Everbest Printing Co. Ltd

Brief Contents

Part I: Preparing to Write

1 The Challenges of Writing About Art

2 Looking at Art

3 Analyzing Art

Part II: The Writing Process

4 Generating Ideas

5 Researching Art

6 Developing Your Thesis

7 Considering Structure and Organization

8 Attending to Style

9 Revising Your Work

Glossary of Art Terms

Revision Checklists

Illustration Credits

Contents

Part I: Preparing to Write

1 The Challenges of Writing About Art 13

WHAT IS ACADEMIC WRITING? 15

GETTING STARTED 16
Consider What You Know
(And What You Need to Know) 16
Consider How to Think Academically 17
Summarize 19
Evaluate 23
Analyze 24
Synthesize 26

ADOPTING A RHETORICAL STANCE 28
Consider Your Position 28
Consider Your Audience 30

CONSIDERING TONE AND STYLE 32

2 Looking at Art 35

GETTING STARTED 35

THE IMPORTANCE OF TAKING NOTES 39

Asking "Why?" 40

Visual Approaches in Art 42

Representational Art 42

Abstract Art 46

Nonobjective Art 50

Artistic Content 53

WHAT ARE YOU LOOKING FOR? 54

3 Analyzing Art 59

FORMAL ANALYSIS 60

Describing Formal Properties of Art 61

Doing Formal Analysis: A Checklist 64

Media/Materials/Fabrication Techniques 70

INTERLUDE: EXPLORING MEANING 78

Considering Content 78

The Relationships Between Form
and Content 81

Explicit and Implicit Meaning 83

Cultural Attitudes and Ideals 87

CULTURAL ANALYSIS 89

Socioeconomic Status 90

Gender 95

Race, Ethnicity, and National Origin 100

Sexual Orientation and Identity 104

Contents

HISTORICAL ANALYSIS 107
 Basic Approaches to Art History 110
 Questions to Generate Analysis 119

Part II: The Writing Process

4 Generating Ideas 123

HOW TO GENERATE IDEAS 123
 Conversation 124
 Brainstorming 124
 Freewriting 127
 Discovery Draft 129
 Five Ws and an H 131
 Tagmemics 134
 Aristotle's Topoi 136

DEVELOPING YOUR IDEAS 140
 Nutshelling 141
 Broadening Your Topic 143
 Focusing Your Topic 146

THINKING BEYOND THE FRAME 148

5 Researching Art — 153

UNDERSTANDING PRIMARY AND
SECONDARY SOURCES — 153

USING SOURCES — 154
Summarize Your Sources — 155
Categorize Your Sources — 156
Interrogate Your Sources — 157
Annotate Your Sources — 159
Make Your Sources Work for You — 159

KEEPING TRACK OF YOUR SOURCES — 161

CITING SOURCES — 161

6 Developing Your Thesis — 165

WRITING A THESIS SENTENCE — 165

ALTERNATIVES TO THE THESIS SENTENCE — 167
The Implied Thesis — 169

TURNING YOUR IDEAS INTO A THESIS — 171

THE THESIS SENTENCE CHECKLIST — 174

7 Considering Structure and Organization — 177

LET YOUR THESIS DIRECT YOU — 177

SKETCHING YOUR ARGUMENT — 179

OUTLINING YOUR ARGUMENT — 180

Contents

CONSTRUCTING PARAGRAPHS 182
What Is a Paragraph? 182
What Should a Paragraph Do? 183
Writing the Topic Sentence or Guiding Claim 184

DEVELOPING YOUR PARAGRAPHS 186
Evidence 186
Arrangement 188
Cohesion 189

INTRODUCTIONS AND CONCLUSIONS 193

8 Attending to Style 199

THE BASIC PRINCIPLES OF THE SENTENCE 200
Focus on Actors and Actions 200
Be Concrete 202
Be Concise 205
Be Cohesive 206
Be Emphatic 209
Be in Control 210
Write Beautifully 211

9 Revising Your Work 213

WHY AND HOW TO REVISE 213

DEVELOPING A CRITICAL EYE 217

ANALYZING YOUR WORK 220

TRANSFERRING WHAT YOU HAVE
LEARNED TO OTHER COURSES 224

Glossary of Art Terms **226**

Revision Checklists **245**

Illustration Credits **248**

1

The Challenges of Writing About Art

What's so hard about writing about art? After all, most of us look at hundreds, if not thousands, of images every day. We're extremely attuned to viewing and processing visual stimuli in many different forms. Is looking at art—whether it's Leonardo da Vinci's painting *Mona Lisa*, Auguste Rodin's sculpture *The Thinker*, Dorothea Lange's photograph *Migrant Mother*, or El Anatsui's **assemblage** *Between Earth and Heaven*—really all that different an experience?

The answer to that question is more complex than it may seem. While we certainly use the same perceptual faculties to look at art as we use to take in all the other images we look at in our lives, the act of looking is only the first step in a longer process of engaging with art in ways that will enable us to write about it. In particular, engaging with art requires us not simply to look at it, but also to look at it closely and attentively, often with a sustained focus that is very different from

the quick glance that we use to process the constant influx of images we experience on a daily basis.

When your art or art history professor asks you to write about an artwork, an art exhibition, or something similar, it is precisely this close and attentive looking that you're expected to engage in. For instance, you need to pay attention to the various **formal** properties of an artwork, such as its use of **line**, **shape**, and **color**. You need to consider the careful choices an artist has made in relation to these formal properties. You also need to think about the relationship between these formal properties and the **content** that the artist has chosen to depict. Similarly, you need to consider the technical training and skills that are required for an artist to work with a specific type of artistic material, such as **oil painting**, bronze **casting**, or **woodcut** printing. You'll want to think about why an artist decided to work with one set of materials rather than another. In some cases, you also need to think about the formulation of an artistic **style** or other art historical development, often resulting from the contributions of many artists.

You might also think about artworks in the **context** of when, how, and why they were made, as well as by and for whom. Once you've considered the context of the artwork's production, its reception by viewing audiences, and its relationship with the culture in which it was made and first viewed, you'll be able to *synthesize* your analysis of the artwork and its context. In short, you'll be able to write a

paper that transforms your thoughts and responses into writing that is appropriately academic.

Before we get into the thick of this subject, let's tackle the most general question of all.

What Is Academic Writing?

Simply put, academic writing (sometimes called "scholarship") is writing done by scholars for other scholars—and that includes you. As a college student, you are engaged in activities that scholars have been engaged in for centuries: You read about, think about, argue about, and write about important, intriguing, or controversial ideas. Being a scholar, however, requires that you read, think, argue, and write in certain ways. You will need to make and support your claims according to the customary expectations of the academic community.

How do you determine what these expectations are? The literary theorist Kenneth Burke has famously described scholarship as an ongoing conversation, and this idea may be helpful.[1] Imagine you have just arrived at a dinner party. The conversation (which in this case is about art) has already been going on for quite a while when you arrive. What do you do? Do you sit down and immediately voice your opinions? Or do you listen, try to gauge the lay of the land, determine

1 Kenneth Burke, *The Philosophy of Literary Form* (Berkeley, CA: University of California Press, 1941), 110–11.

what contribution you might make, and only then venture to make it?

The etiquette that you would employ at the dinner party is precisely the strategy that you should use when you write academic papers. In short, listen to what other scholars are saying. Familiarize yourself with the scholarly conversation before jumping in. Pay attention both to *what* is said and *how* it is said. A book like the one you're reading now can be a helpful "dinner companion" that helps get you up to speed and fills you in on the conversation that preceded you. But you should make use of other resources, too. Your professor, for instance, is a living, breathing expert on what art historians, critics, and scholars from related disciplines care about. Books, journals, and reputable Internet sites also offer an opportunity to eavesdrop on the ongoing scholarly conversation about art. Once you understand the substance of that conversation, you can begin to construct informed arguments of your own.

Getting Started

CONSIDER WHAT YOU KNOW
(AND WHAT YOU NEED TO KNOW)

A short paper written in response to a viewing of El Anatsui's (b. 1944) *Between Earth and Heaven* (2006), for example, may not require you to be familiar with Anatsui's other artworks

or to have a broad familiarity with art's **formal elements**. In other words, you don't need to "know" about art—its history, or how it's created—in order to formulate a response to it. All you need to know is what a particular artwork made you feel, or what it made you think about.

If you're asked to write an *academic* paper on the artwork, however, you'll need to know more. In order to describe and explain Anatsui's artwork accurately, you'll need to have a firm grasp of the formal and technical elements of assemblage and weaving. You might want to examine other examples of Anatsui's work, so that you develop a better understanding of the specific materials and practices that the artist uses. In addition, you'll need to consider the histories of these materials and practices, so that you can understand what themes Anatsui explores in his work. Finally, if you're writing about this artwork in an upper-level art history class, you'll need to be aware of different art historical and critical perspectives on Anatsui's work, on both historical and contemporary African art, and on weaving and assemblage practices more generally, so that you can "place" your argument within ongoing critical conversations.

CONSIDER HOW TO THINK ACADEMICALLY

The aim of thinking academically is to come up with new knowledge or new ideas. Scholars in all fields build on existing knowledge: They do not replicate what is already known,

or what has already been said. Similarly, in terms of artworks that you will write about, your goal is to come up with fresh observations. It's not enough to summarize in a paper what's obvious, or what's already known and discussed. You must also add something new, something of your own, to the ongoing scholarly conversation.

Understand, however, that "adding something of your own" is not an invitation to allow your personal associations, reactions, opinions, or experiences to dominate your paper. To create an informed argument, you must first recognize that your writing should be analytical rather than personal. In other words, your writing must show that your reactions to an artwork have been framed in a critical, rather than a personal, way.

This is not to say that your personal responses to art are irrelevant. Indeed, they are often good starting points for the academic work to come. For instance, being confused by Pablo Picasso's (1881–1973) painting *Les Demoiselles d'Avignon* (1907) can be the first step on the way to a strong analysis. Interrogate your confusion. Why are you confused? Which elements of the painting contribute most to your confusion? How does the painting experiment with line, shape, and color to produce a new, experimental method of rendering the figure in **space**? How does the use of line, shape, and color encourage you to rethink our understandings of, and assumptions about, the relationships between painting and visual perception?

Interrogating your personal responses is the first step in making sure that your argument will be appropriately academic. But to further ensure that your responses are critical rather than personal, you will want to subject them to the following critical thinking processes: summary, evaluation, analysis, and synthesis.

SUMMARIZE

The first step in thinking critically about any artwork is to summarize what it depicts and how it does so. You can construct several different summaries, depending on your goals, but beware: Even the most basic of summaries—a description of what you see—isn't as simple as it seems. It's difficult to write both economically and descriptively, discerning what's essential to your discussion and what's not.

Consider this: Mary Cassatt's (1844–1926) *Woman Bathing* (1890–91) (fig. 1, p. 20) is a very complex image. This color **print** draws upon a number of visual sources—including the earlier work of Édouard Manet (1832–1883) as well as eighteenth- and nineteenth-century Japanese **woodblock** prints (e.g., see fig. 14, p. 196) that were popular and circulated widely in Paris in the late nineteenth century—to depict a woman washing herself in a domestic interior. Further complicating matters is that Cassatt's artwork makes use of two different printmaking techniques, **drypoint** and **aquatint**, that together create an image with especially thin **outlines**

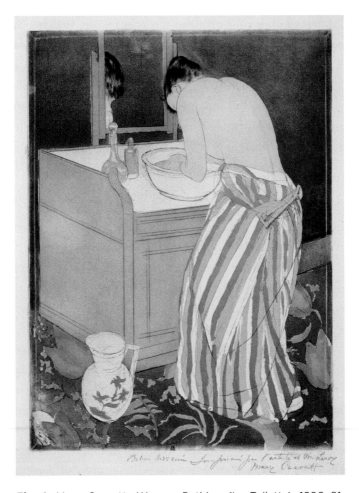

Fig. 1: Mary Cassatt, *Woman Bathing (La Toilette)*, 1890–91. Drypoint and aquatint, printed in color from three plates; fourth state of four, 14$5/16$ x 10$9/16$ in. (36.4 x 26.8 cm). Metropolitan Museum of Art, New York.

combined with washes of color that recall **watercolor** paintings. What is more, Cassatt employs these two printmaking techniques to depict several different richly **patterned** fabrics and forms within the private setting of the domestic scene, offering viewers an extensive array of visual stimuli to decipher. As a result, this artwork can be difficult to describe, though H. H. Arnason and Elizabeth Mansfield provide a helpful account of it in their *History of Modern Art*:

> Cassatt's print, *Woman Bathing* . . . , presents a humble **subject**, which she animates through the play of strong **contour** line and surface patterning. The figure's boldly striped garment energizes the floral pattern of the carpet, with both surfaces merging into a single **plane**. Traditional perspectival space is here abandoned in favor of color, line, and **form** arranged for the benefit of visual **harmony** rather than documentary information.[2]

What makes this description effective? It identifies the most notable or distinctive characteristics of Cassatt's artwork, focusing on the formal properties of line, pattern, and space and the ways these properties interact with one other, without being sidetracked by too much visual complexity. The authors also include a brief description of the content, making sure

2 H. H. Arnason and Elizabeth Mansfield, *History of Modern Art, Seventh Edition* (Boston: Pearson, 2013), 27 (emphasis added).

that their sentences are clear and straightforward. In the end, the authors produce a summary that is faithful to the artwork but doesn't overwhelm the reader with details.

Composing a description of what you see can prove very useful when you are writing about art. In most student essays about artworks, visual description is an important touchstone for the paper's argument: It helps ground your argument in concrete details. Summarizing an artwork's visual properties can help you see its particular formal experiments, technical processes, and content. But if you choose to include visual description in an academic essay, use it judiciously—as a tool that aids your analysis, not as an excuse to avoid analysis. A common beginner's error is to submit a paper that claims to offer an argument about art but instead merely describes the art. Use an artwork's visual properties to support your argument, but don't allow those elements to overwhelm it.

Finally, when thinking critically about an artwork, you needn't limit yourself to visual description. Equally useful, depending on your purpose, are summaries of an artistic style, a specific technical development, the work of an individual artist across the scope of his or her career, summaries of the artwork's critical reception, and so on. The point is that summarizing is useful in helping you clarify what you know about an artwork or artistic development, laying the foundation for the more complex processes to come.

EVALUATE

Evaluation is an ongoing process. You begin evaluating an artwork the moment you encounter it, and you will continue to evaluate and re-evaluate as you write. It's important to understand that evaluating an artwork for an academic paper is different from simply having a personal opinion or response. When you evaluate for an academic purpose, you must find and articulate the *reasons* for your response. What in the artwork is leading you to respond a certain way? Looking at Cassatt's print, for instance, you might find yourself intrigued by the artist's use of color; or the juxtaposition of different patterns; or the thin, at times delicate outlines that she achieves with her use of the drypoint printing technique. What about these visual properties intrigues you? The ways that Cassatt uses colors with very little tonal variation? The ways that some of the patterns seem, at first glance, to clash with one another? The ways that Cassatt uses the delicate outlines to define what appear to be **three-dimensional** forms in what are otherwise flat, **two-dimensional** fields of color? Something else? In other words, can you identify a particular feature of these visual properties that especially interests you? By asking these questions, you are straddling two intellectual processes: experiencing your own personal response and analyzing the art.

Evaluation also encourages you to compare and contrast an artwork with other artworks that you've seen. How does

Woman Bathing compare with other prints Cassatt produced, or with prints produced by other Impressionists working in France at the same time? How does it compare to works Cassatt produced in other materials, such as painting? How is it influenced by artworks produced at earlier moments? How does it influence later artworks? Evaluating what's similar across a variety of artworks, and what's distinctive about an individual artwork or an individual artist's work, allows you to isolate those aspects that are most interesting—and most fruitful—to investigate further.

ANALYZE

In order to analyze an artwork successfully, your first task is to consider the parts of your topic that most interest you. You will then examine how these parts relate to one another or to the whole. To analyze Cassatt's *Woman Bathing*, you will break the artwork down by examining particular visual and technical components, including the range and selection of colors used; the interplay of color and patterns in the image; the tensions between **illusionistic pictorial** space and flat, two-dimensional forms; the overall arrangement of elements within the scene; the content the artist depicts; and so on. In short, you'll ask: What are the key components of Cassatt's print, and how do these components contribute to the distinctive properties of this artwork? Finally, how do these components contribute to

Cassatt's work more generally, and/or to Impressionism as a whole?

Artworks are filled with so much information that it is difficult to grasp even a small part of their formal arrangement and cultural significance in one viewing. You can learn a good deal by carefully analyzing individual formal properties, examining them several times, and taking notes each time. Looking at artworks multiple times enables you to recognize how the parts of an artwork interrelate—how some elements complement other elements, or how some elements relate to earlier or later artistic developments. Above all, multiple viewings will allow you to consider the various elements of an artwork in more depth, which will help you to identify their particular relevance or importance.

Sometimes, you will analyze multiple artworks in conjunction with one another. In these cases, you'll also want to pursue multiple viewings. These multiple viewings will help you consider different areas for analysis and perceive connections across different artworks. You might find, for instance, that a group of artworks shares a particular visual or technical element. Or you might discover that a particular theme draws your attention and becomes the focus of your analysis.

One further point: If possible, when writing about art, it is always beneficial to view an artwork or artworks in person. Multiple firsthand viewings of art will definitely bring further strengths to your analytical efforts. If you do not have direct,

in-person access to the art you are writing about, try to find very high-quality reproductions of the work to view, such as those found on many museum websites, in exhibition catalogs, and the like. Similarly, if possible, look for reproductions of close-up views (sometimes called "detail" views) of the artwork(s) you are writing about. These detail views often provide additional visual information that will assist you in your analysis.

Whatever your focus, when you analyze, you break the whole into parts so that you might see the whole differently. When you analyze, you find things to say.

SYNTHESIZE

When you synthesize, you look for *connections* between ideas. Consider, once again, Cassatt's *Woman Bathing*. In analyzing this artwork, you might make some observations that at first don't seem to gel. Or you might have read various critical perspectives on Cassatt's work, all of them in disagreement with one another. Now would be the time to consider whether these disparate elements or observations might be reconciled, or synthesized. This intellectual exercise requires that you create an *umbrella argument*—a larger argument under which several observations and perspectives might stand.

In an analysis of Cassatt's *Woman Bathing*, for example, you might observe elements that initially seem at odds with certain definitions of Impressionism as a style. For

instance, you might consider the ways in which Cassatt's content appears to differ from that of other Impressionists, such as Claude Monet (1840–1926) or Pierre-Auguste Renoir (1841–1919). Specifically, you might examine the ways in which Cassatt tends to depict women in private spaces and engaged in domestic activities, rather than the more **conventional** Impressionist landscape scenes or the images of public leisure activities in nineteenth-century Paris. You might note that, in these scenes of women in private, domestic life, Cassatt depicts individuals she knows personally and settings readily available to her.

Through this particular content, you might then argue that Cassatt's work expands the types of subject matter commonly included in Impressionist ideas about what kinds of scenes and settings were central to late nineteenth-century modernity. This might lead you to think more broadly about how gender has impacted different assumptions about Impressionism. Or you might turn to other examples of Cassatt's work in order to explore the ways in which gender contributed to ideas about late nineteenth-century modernity. Or you might consider examples of work by other artists that similarly expand the subject matter seen in Impressionism. Any of these explorations can enable you to transform a list of observations into a powerful and intriguing argument.

Adopting a Rhetorical Stance

When writing an academic paper, you must consider not only what you want to say, but also the audience to whom you're saying it. In other words, it's important to determine not only what you think about a topic, but also what your readers are likely to think and how they might respond to your position. What biases do your readers have? What values, expectations, and knowledge do they possess? For whom are you writing, and for what purpose?

When you begin to answer these questions, you have started to reckon with what has been called the "rhetorical stance," which refers to the position you take as a writer in terms of both the subject and the readers of your paper.

CONSIDER YOUR POSITION

Let's first consider your relationship to the topic you're writing about. The first thing that you'll want to determine when approaching your topic is what kind of paper you are being asked to compose. In other words, the assignment will let you know the kind of relationship you are expected to develop with your topic. For example, if you are asked to write a response paper, such as an exhibition review, you are being encouraged to take a stand. In your review, you might identify the ways you think the theme of the exhibition—as well as the ways the artworks are organized and displayed in

relation to one another—are (or are not) effective. You might also assess the ways in which an individual artwork or certain selected artworks display various artistic skills and degrees of technical proficiency. Regardless of what response you have, you need to have a clear sense of your "relationship" to your response so that you can communicate clearly, to your reader, what this response is and what factors contribute to it.

More often in your art or art history class you will be asked to write not simply a response paper, but a more in-depth analysis paper—a paper that looks at *how* something is constructed and then discusses the historical and/or cultural significance of that construction. (We discuss at length the process of writing an analytical paper in Chapter 3, "Analyzing Art.") For now, it's sufficient to note that writing an analysis paper also requires you to have a response, and then to make an argument about your response. In other words, when you analyze art, you don't want simply to describe what the artist did. You also want to indicate why these decisions matter—why these decisions were important to a particular artwork or artistic development, or to art and art history in general. You'll also want to convey to your reader a sense of why your analysis matters to the ongoing conversation about the artist's work. In the end, argument is a crucial part of any analysis paper.

To ensure that your relationship to your topic is appropriately analytical or argumentative, ask yourself some questions. First, consider whether your relationship to your

topic is rooted in argument and analysis, or in opinion. As we suggested earlier, opinion is subjective and can be justified by the opinion-holder's personal tastes and preferences; analysis and argument require more objective evidence and must be defended via reason and research. To ensure that you are producing argument or analysis rather than opinion, you will first want to consider why you chose this particular topic. Why did you find an artwork, or some aspect of it, more important or interesting than others? What personal feelings or biases does the artwork (or this particular aspect of the artwork) engage? Can you defend these biases critically? Have you reviewed and thought carefully about responses to the artwork that might challenge yours? Might some part of your response to the artwork cause readers to discount your paper as one-sided or uncritical? If any of these questions raise a flag for you, rethink your relationship to your topic with these questions in mind. Use them to transform personal opinion into academic analysis and argument.

CONSIDER YOUR AUDIENCE

Your position on a topic does not, by itself, determine your rhetorical stance. You must also consider your readers. In the college classroom, the audience is usually your professor and your classmates—although occasionally your professor will instruct you to write for a more particular or more general

audience. No matter who your readers are, you'll want to consider them carefully before you start to write.

What do you know about your readers and their stance toward your topic? What are they likely to know about the topic? What biases are they likely to have? Moreover, what effect do you hope to have on the readers? Is your aim to be controversial? Informative? Entertaining? Will readers appreciate or resent your intent?

Once you've determined who your readers are, you will want to consider how you might best reach them. If, for example, you're an authority on a particular subject and you're writing for readers who know little or nothing about that subject, you might want to take an informative stance. If you aren't yet confident about a topic and you have more questions than answers, you might want to take an inquisitive stance.

In any case, when you're deciding on a rhetorical stance, choose one that allows you to be sincere. You don't want to take an authoritative stance on a subject if you aren't confident about what you're saying. On the other hand, don't avoid taking a position on a subject—readers are very often frustrated by writers who refuse to take a clear stance. What if you are of two minds on a subject? Declare that to the reader. Make ambivalence your clear rhetorical stance.

Finally, don't write simply to please your professor. Though some professors find it flattering to discover that all of their students share their positions on a subject, most of

us are hoping that your argument will engage us by telling us something new about your topic—even if that "something new" is simply a fresh emphasis on a minor detail. Moreover, it's impossible for you to replicate the ideal paper that exists in your professor's head. When you try, you risk having your analysis compared to your professor's. Is that really what you want?

Considering Tone and Style

So now you understand what's required of you in an academic paper. You need to be analytical. You need to create an informed argument. You need to consider your relationship to the topic and to the reader. But there is one more aspect of your writing that you must consider—particularly in terms of your relationship with your reader—and that is the tone and style of your work.

The tone and style of academic writing might at first seem intimidating. Students new to academic writing sometimes feel that they have to employ the jargon and the complex sentences that they find in scholarship. But that's not the case. Professors don't want imitation scholarship. They want students to write clearly and intelligently on matters that they, the students, care about. The tone of an academic paper must be clear and inviting. Your task is to render a good idea in clear language that is a pleasure to read.

After all, professors are human beings, capable of boredom, laughter, irritation, and awe. They have lives outside of their duties as teachers, and they don't appreciate having their time wasted any more than you do. Understand that you're writing to someone who will be delighted when you make your point clearly, concisely, and persuasively. Understand, too, that this person will be less delighted if you have inflated your prose, pumped up your page count, or tried to impress by using terms that you didn't take the time to understand. (For more on how to craft an appropriate but engaging academic tone and style, see Chapter 8, "Attending to Style.")

2

Looking at Art

Before you start writing anything about art, you must first look at it—closely, with an analytical eye, and armed with the specialized vocabulary that is an integral part of serious study. Looking closely at artworks, and taking notes as you do so, is the first step to having something interesting to say about them. This chapter should help you get this process started.

Getting Started

Some art and art history courses require museum and/or gallery visits to attend art exhibitions. Often, the artworks on display are the ones that your professor wants you to write about. Even if visiting art exhibitions isn't required by your instructor, viewing art in person is something that every student of art should experience. Art often looks different in person than it does in photographic reproductions; for

instance, you can see the physical **texture** of paint, and you can walk all the way around a **freestanding** sculpture. You can also get a much better sense of the **scale** of an artwork by viewing it in person, just as you have the opportunity to look closely at any element or area of an artwork that interests you.

In addition, the reactions of other viewers at an art exhibition can help you notice things that you might overlook if you view art only in the privacy of your own room. Other viewers might take a particular interest in an artwork on display that you might not have noticed, or they might position themselves to look at an artwork from an angle that you wouldn't have tried. Use the time at an exhibition to enjoy the experience along with other viewers, but also to note those elements of the art that other viewers seem to have a strong reaction to. If you can manage it, take some notes about the art before, during, and immediately after you view it.

Also, if you have access to a camera (on your cell phone or similar device), and if the exhibition venue permits it, take photographs of artworks that especially interest you. When photographing artworks, it is also a good idea to photograph relevant supporting materials that are part of the display, such as wall texts that identify artist names and artwork titles and dates (among other details). This photographic documentation of your viewing experience will be extremely valuable when you later revisit your responses and begin to organize your ideas.

Indeed, this kind of documentation constitutes one of the main ways that most of us view artworks when writing about

art—via photographic reproductions. Until recently, such reproductions were available primarily in printed forms, meaning in books and magazines. In print forms, reproductions of artworks often include only a partial, and sometimes quite limited, selection of an overall set of artworks that may be of interest.

Today, photographic reproductions of artworks are more widely available than ever before, thanks to the vast repository of resources available online on museum and gallery websites and in such online image databases as Artstor, WikiArt, and the Google Arts and Culture project. These online resources are enormously useful, since they include a much larger number and selection of artworks than is usually found in print resources.

These online resources also sometimes include reproductions of other kinds of materials, such as historical documents that can assist us in gaining a better understanding of an artistic development over time. In some cases, museums and galleries will post short videos of artists discussing their own work, or of scholars discussing the significance of a particular artistic **medium** or style. Some online features allow viewers to "zoom in" on digital reproductions to gain close-up views of artworks, providing more nuance and detail than would be possible even when looking at an artwork in person. Some websites also allow you to download digital images, which can be useful resources for many different types of writing assignments.

The benefits of online resources for private viewing and the study of art thus can't be overstated. But in drawing upon online resources, it is important to ensure that they are reliable. For instance, if you are viewing artworks online, you need to make sure that the images reproduced depict original, authenticated artworks. Museum and art gallery websites are almost always trustworthy sources of images and information, as are such established image databases as Artstor. Sometimes, however, if you search online for a famous artwork or a well-known artist, you will encounter websites that offer contemporary copies of artworks for sale. These may be perfectly legitimate online businesses, but they are *not* reliable sources for images of artworks and related information you might use to assist you with a writing assignment.

Similarly, if you download digital reproductions of artworks from a reliable website, keep in mind that these materials are frequently protected by copyright laws, which permit you to use them only in very specific ways. For instance, it may be permissible to include a downloaded image in a writing assignment that you complete in an official educational context and submit to an instructor, whether in hard copy or electronic form. But it might not be permissible for you to post the same image on a social media site, even if your social media post described your work on the same writing assignment.

In other words, while online resources provide an abundance of important materials that assist us in writing about

art, we must use these materials thoughtfully and appropriately. You should take advantage of these resources—again, provided they are from reliable sources—as much as is relevant to your writing about art.

The Importance of Taking Notes

Taking notes is an essential part of preparing to write about art. Whether you are recording your observations while you are on-site at an art exhibition, copying key points of a classroom lecture or group discussion, or jotting down stray ideas over the course of your day, note-taking can capture observations, attitudes, and insights that you otherwise may not recall when it comes time to actually compose your paper. Because memory is less perfect than we often assume, you need to adopt good note-taking practices. There are no rules for note-taking, but here are a few useful hints to start:

Make your notes as succinct as possible.

Resist the temptation to record all of your observations at once. Focus instead on the significant elements of an artwork. Assuming you have access to a photographic reproduction of the artwork, you can view the artwork again later for more detail.

Take photographs or make quick sketches of particular elements of an artwork that you want to discuss. These will prove useful when you begin to write. If you're

viewing on a computer, sometimes you can capture screenshots and/or download images of an artwork and insert them into your paper as illustrations.

Review and organize your notes according to key elements of artistic production or key areas of analysis, such as formal properties, content, and context. As you review, look for notable visual features or historical developments. Do this while your thoughts about an artwork are fresh in your mind. Many students come up with ideas for their papers when they reorganize observations in their notes.

Note-taking is a highly personal activity. Some people meticulously record information in a systematic way, while others haphazardly scrawl ideas and doodles. You should adopt whatever method works for you. That said, there are a few strategies for note-taking that have proven useful to art and art history scholars and students that you might consider using or adapting to your own purposes.

ASKING "WHY?"

When viewing an artwork for the first time, the most important thing is to be alert to elements of the artwork that strike you as different, memorable, or puzzling. Taking note of these things, and framing your notes about them in the form of questions, will prompt you during subsequent viewing(s)

to return to those elements to see if you can answer your questions, and thus perhaps discover something about the artwork that is interesting enough to write about. Here are some concrete examples of questions about artistic developments and specific artworks that a student might ask:

Why do some images of the Buddha depict the figure with his right hand raised?

Why are the illustrations in medieval **manuscripts** typically called "**illuminations**" rather than "illustrations"?

Why are the *moai* (stone sculptures of human heads and figures) created by the Rapa Nui people on Easter Island so large?

Why was the restoration of Michelangelo's paintings in the Sistine Chapel so controversial?

Why did Johannes Vermeer create so many paintings that depict domestic interior scenes?

Why do many examples of Aboriginal bark painting from Australia use an x-ray style to depict human figures and/or animals?

Why do Impressionist paintings look so **sketch**-like?

Why are there what appear to be visual distortions, or pictorial mistakes, in many of Paul Cézanne's **still-life** paintings?

Why did Piet Mondrian use only the three **primary colors** (red, yellow, and blue) and black, white, and

gray in so many of his paintings? And why did he call this work Neo-Plasticism?

Why does Cindy Sherman use herself as the model in all of her photographs?

Such questions will plant the seeds for productive reviewing, analysis, and writing.

VISUAL APPROACHES IN ART

During your first question-generating viewing and note-taking session, one of the first things you will observe is the visual approach that artists take in creating their work. Specifically, art historians and scholars from related disciplines frequently distinguish between three different visual approaches in art: **representational**, **abstract**, and **nonobjective**.

REPRESENTATIONAL ART

Most of us are aware of representational approaches in art. With these approaches, artists produce visual forms that resemble—and sometimes try to replicate—the appearances of the world around us. Because of this, untrained viewers sometimes find the experience of looking at representational artworks to be similar to looking at an actual object or scene in the world. However, there are important differences in

these viewing experiences, which you will learn to identify and analyze as you spend more time learning about—and looking at—art.

In two-dimensional pictorial media, including drawing, painting, printmaking, and some **relief** sculpture, representational practices that create the appearance of three-dimensional space are called *illusionistic*. To create two-dimensional pictorial illusionism, artists use specialized techniques (such as **linear** or **one-point perspective**) to create the image of a space that recedes away from the viewer on what appears to be the other side or "inside" of the artwork. Looking at illusionistic imagery can thus seem like looking through a window or doorway. When we look at these kinds of representational artworks, we can imagine ourselves entering into the illusionistic space. Sometimes artists use illusionistic representation in ways that so closely resemble the recognizable world that we are almost tricked into believing we see the actual objects or scenes depicted, rather than representations of them. This type of representation is known as ***trompe l'oeil*** (a French phrase that, when translated, means "fool the eye").

In such three-dimensional artistic media as **sculpture in the round**, artworks are physical objects that themselves occupy space, which means they rarely employ the techniques that produce two-dimensional illusionism. Many sculptures, however, are highly representational, especially those that depict the human figure. In fact, many **figurative** sculptures approximate not only the physical properties of

flesh, bone, and bodily movement, but also the size and scale of human bodies. When we encounter these extremely **naturalistic** figurative sculptures, it can sometimes seem as if we are looking at an actual human being rather than at an object crafted from stone, metal, or another material.

In other words, representational approaches in art often produce visual forms that are very familiar, which may be one reason that representational art appeals to many viewers. Some of the best-known examples of visual art—such as Michelangelo's (1475–1564) paintings on the ceiling of the Sistine Chapel (1508–12) and Rodin's (1840–1917) figurative sculpture *The Thinker* (first conceived in 1880–81)—are renowned above all for their **realistic** representational forms.

However, there are many different approaches to representation. For instance, some approaches are meant to produce not simply accurately observed, but also **idealized**, forms. Idealized representations are usually based on the appearances of the world around us, but they also attempt to improve upon those appearances, ignoring what might otherwise be perceived as blemishes or irregularities that are often evident in the world. In idealized representation, artists thus refine or perfect the appearances of whatever they have chosen to portray. Idealized representation is prevalent in artistic developments ranging from Classical Greek sculpture to landscape painting in the Northern Song dynasty in China (fig. 2). In addition, idealization is an important feature

of many examples of Italian High Renaissance art, across various media.

In other cases, artists use a more naturalistic or realistic approach to representation, incorporating the many irregularities found in the world into their imagery. Ancient Roman portraiture is often more realistic, incorporating scars and signs of age into its depictions of various individuals. French Realism, practiced in the middle of the nineteenth century, also displays a more naturalistic, even matter-of-fact approach to representation, above all in its imagery of members of the working classes engaged in physical labor.

Sometimes artists use representational approaches to produce imagery that closely approximates the surrounding world but that also combines visual forms we do not otherwise find together in real life. This is the case in certain examples of Surrealist painting in the early twentieth century. Although

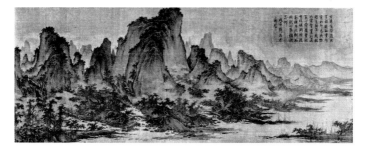

Fig. 2: Attributed to Qu Ding, *Summer Mountains*, c. 1050. Handscroll, ink and color on silk, 17⅞ x 45⅜ in. (45.4 x 115.3 cm). Metropolitan Museum of Art, New York.

these artworks may not make logical visual sense, they do remain examples of representational art, in that Surrealist artists use representation in their efforts to generate imagery and practices from their unconscious minds. This goal is very different from those pursued by artists in Classical Greece, Ancient Rome, the Northern Song dynasty, the Italian High Renaissance, or French Realism.

In other words, while many artists have used representation throughout art history, we should not assume that representation is always meant to function in the same way. Instead, representational approaches usually take shape in relation or response to various social, political, economic, and cultural forces that operate in different historical eras. Indeed, this is true of the two other visual approaches in artistic practice as well.

ABSTRACT ART

In abstract art, visual forms bear less of a direct or immediately recognizable resemblance to the world around us. In many examples of abstract art, artists draw upon their observations of the world, but they depict what they see in less established or familiar ways.

Consider the work of J. M. W. Turner (1775–1851): In a number of his later paintings, Turner used abstracted rather than fully representational imagery. For instance, in *Rain, Steam, and Speed—The Great Western Railway* (1844) (fig. 3),

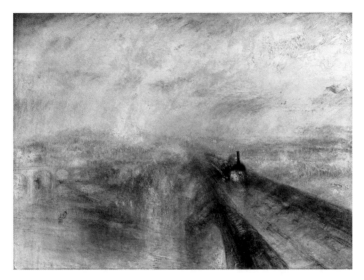

Fig. 3: J. M. W. Turner, *Rain, Steam, and Speed—The Great Western Railway*, 1844. Oil on canvas, 35¾ x 48 in. (91 x 121.8 cm). National Gallery, London.

Turner portrays a train on a railway bridge, but he does so with extremely loose, **painterly** rendering that abstracts these forms. In particular, Turner applied paint in heavily textured areas across the canvas to indicate the clouds and rain in the sky and the steam from the locomotive. This thick, **impasto** paint lacks crisp definition and does not resolve into anything like a familiar or recognizable form. Instead, it obscures even the possibility of visual definition, similar to the ways that clouds and steam frequently reduce visibility and make it difficult (if not impossible) to see forms clearly. Furthermore,

the abstracted areas of paint seem to add weight to the image, again similar to the ways that clouds, rain, and steam can weight the air with moisture. As a result, these abstract forms contribute to an image that itself seems to exude the atmosphere of a cloud- and steam-filled rainy day.

Relatedly, at first glance, many Italian Futurist artworks from the 1910s can confuse viewers, because these artists also did not use standard systems of illusionism. In particular, such Futurist artists as Giacomo Balla (1871–1958), in *Abstract Speed—The Car has Passed* (1913), and Umberto Boccioni (1882–1916), in *Dynamism of a Speeding Horse + Houses* (1915), experimented with visual methods of depicting the optical, physical, and temporal properties of movement. While their artworks lack the easily recognizable forms found in more familiar representational practices, they do portray scenes drawn from life, such as a car speeding through a landscape or a horse galloping toward or in front of a series of houses.

In these ways, while abstract approaches in art can sometimes seem less accurate—and also less skilled—than those found in representational approaches, this is rarely the case. For artists like Turner or the Futurists, creating a visual approximation of a dynamic sensory experience is more important than a meticulously rendered image. Indeed, because Turner's and Balla's paintings and Boccioni's sculpture capture the myriad sensory experiences of their respective scenes, they are arguably even more faithful

or realistic than artworks that reproduce the near-perfect visual likeness of such scenes without any other experiential qualities. In other words, when looking at and writing about art, it is best to avoid judgments about the value or skill associated with one visual approach versus another. These kinds of assumptions can interfere with our observational work and can lead us to formulate ideas and arguments that are, at best, superficial or, at worst, completely uninformed.

In addition, it is important to keep in mind that, because there are different degrees or types of practices in both representational and abstract approaches to art, it is sometimes difficult to identify an artwork as one or the other. For instance, Turner's painting includes one or two more recognizable elements, such as the chimney of the locomotive and a second bridge in the distance, though the rest of the painting provides far less familiar or distinctive imagery. In other words, in some artworks, certain areas are more representational than others, indicating that representation and **abstraction** are not necessarily mutually exclusive.

Relatedly, in Italian Futurism, some of the abstracted elements create imagery that is more readily evident as a landscape or road or part of a horse, while other visual elements do not seem to depict any forms that we might observe in the world. As a result, Balla and Boccioni (among other Futurist artists) could be said to combine an abstract visual approach with the third, nonobjective approach to art, discussed in

more detail below. When we are confronted with individual artworks that merge these different visual approaches, we may need to consider additional sources of information, such as an artwork's title or other examples of an artist's work, to help us determine how best to identify and write about an artwork's visual approach.

NONOBJECTIVE ART

In nonobjective art, artists use such visual properties as line, shape, and color to create forms that bear no connections to recognizable objects or scenes in the world around us. That is to say, in nonobjective art, artists combine visual properties without any reference, direct or indirect, to the observable world. For inexperienced viewers, nonobjective art can be perplexing, even indecipherable; but again, as you gain more knowledge about art, you will develop observational skills that will help you more effectively see and understand nonobjective approaches to art.

Some scholars and critics understand nonobjective art as an approach in which artists take abstraction to such an extreme that any links to the recognizable world ultimately disappear. Others understand this approach as one that emphasizes **geometric** shapes and forms (in contrast to the more **organic** forms often found in abstract art) to such an extent that the artistic imagery becomes divorced from any partial or provisional link (no matter how slight it might be) to the observable world.

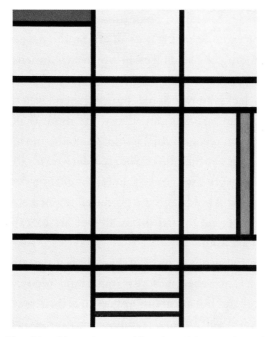

Fig. 4: Piet Mondrian, *Composition in White, Red, and Yellow*, 1936. Oil on canvas, 31½ x 24½ inches (80 x 62.2 cm). Los Angeles County Museum of Art.

Some of the best-known examples of nonobjective art in Western art history are found in modern art from the early twentieth century, such as the Neo-Plastic paintings of Piet Mondrian (fig. 4). Mondrian's use of red, yellow, blue, black, white, and gray in his arrangements of squares, rectangles, and vertical and horizontal lines is not meant to depict any actual objects or figures in the world, even in a simplified

way. Instead, Mondrian's paintings use their intentionally limited pictorial vocabulary as an attempt to develop a new understanding of visual form, in which two-dimensional art no longer operates according to the standards of illusionism and lacks conventional figure/ground relationships. For Mondrian, art was intended to be more than an imitation of the recognizable world; it could move beyond these qualities (which he considered derivative) to become a unique sensory experience that might change the way we see the world. Mondrian thus produced nonobjective paintings that use the formal properties of art to explore the nature of art itself.

In identifying one or more of these three visual approaches used in art, however, it is also important to pay attention to cultural and historical differences in artistic practice. For instance, different cultural traditions have different attitudes about what constitutes an idealized approach to depicting recognizable forms, just as, within some cultural traditions, what counts as idealized imagery changes over time. Also, some cultures use what might be described as visually abstract or apparently nonobjective forms to represent gods, goddesses, and other religious entities. In other words, when you interpret artworks, you need to be careful. Even if you initially identify a particular visual approach in a work of art, it is always a good idea to follow this up by examining the artwork's cultural and historical context, as well as its function within that context. Through these efforts, you will

develop more breadth and depth in your knowledge about art, which will enhance your subsequent analyses. We will address these issues and related aspects of analyzing art in the next chapter.

ARTISTIC CONTENT

When you begin looking at the art you are going to write about, you will also want to take some notes about the content or subject matter it portrays. There are many different types of content in visual art, all of which can be used in various ways to communicate a wide range of meanings.

For instance, in Dutch art during the sixteenth and seventeenth centuries, artists often used still-life content to explore the temporary, fleeting properties of life and human mortality in artworks that are sometimes called **vanitas** scenes (see fig. 7, p. 112). In contrast, during the early twentieth century, Georges Braque and Pablo Picasso used still-life content as a way to both develop Analytic Cubist experiments with visual form and explore café culture and related social phenomena in Paris at the time.

Also, while abstract and nonobjective artworks may initially appear to have no content, all artworks have some kind of intent or meaning. In some abstract artworks, recognizable content has been modified and disguised via a particular visual language. In some nonobjective artworks, content is not drawn from the visual world but is instead linked to

feelings or sensations that we may not typically experience as visual, such as happiness, sorrow, curiosity, or exuberance.

Whatever the case may be, content is almost always an integral element of visual art. In taking notes about content, it can be useful to write a short description of the subject(s) depicted and/or the feelings an artwork evokes, to experiment with translating content from visual into written language.

What Are You Looking For?

You may wonder at this point just what all these tools and tips amount to. What, exactly, are you looking for? What's the point?

To answer these questions, first we need to recognize that every artwork is a complex synthesis—a combination of many separate, interrelated elements that form a coherent whole. Anyone attempting to comprehend a complex synthesis must rely on *analysis*—the act of taking something complicated apart to figure out what it is made of and how it all fits together.

A chemist, for example, breaks down a compound substance into its constituent parts to learn more than just a list of ingredients. The goal usually extends to determining how the identified individual components work together toward some sort of outcome: What is it about this particular mixture that makes it taste like strawberries, or grow hair, or kill cockroaches? Likewise, analyzing art involves more than describing the appearance of an artwork, identifying

the content, or noting the tools and techniques that were used to create it. The investigation is also concerned with the function and potential effect of that combination: Why does an artwork depict its content the way it does? Why does an artwork make you think differently about the way you see the world, or about the way vision operates? Why do some artworks make you want to look at them again and again? The search for answers to these sorts of questions boils down to one essential inquiry: What does it mean?

Intriguingly, artworks sometimes have ways of hiding their techniques and meanings. For instance, because representational artworks resemble the recognizable world, their technical properties and meanings can be "invisible" to the viewer. In looking at artworks that appear to replicate reality, such scenes can seem so familiar that we assume we already see everything that matters. We also might assume that we already know what an artwork means because it recalls our own experience in some way. While these assumptions can be informative, they are not always accurate. They are especially problematic when they convince us that there is no reason for us to look at artworks closely. If we neglect to examine the different elements of an artwork with care, we will almost certainly overlook some key features that would otherwise contribute to a more comprehensive, nuanced understanding of art.

Because many abstract and nonobjective artworks lack any resemblance or reference to the recognizable world, these

artworks can also seem mysterious. In many cases, when we are presented with abstract or nonobjective imagery, it can seem to hide any decipherable artistic content that could contribute to an artwork's meaning. Similarly, such artworks can seem to trick viewers, attracting our attention only to confuse or frustrate us by withholding what we might expect to see when looking at art. In these instances, we might deflect our confusion by assuming that abstract and nonobjective artworks are unskilled, though, as noted above, this is almost never actually the case. We might also dismiss such artworks as meaningless nonsense, thus denying their importance before we have even begun to look closely and carefully at what they do have to offer. Instead, it is almost always worth considering what it is about an unfamiliar artwork that creates our confusion or frustration, as this can be a highly informative—and sometimes quite exciting—starting point for analysis.

In analyzing artworks, scholars and critics have a specialized vocabulary that they use to articulate notable visual features of and meanings associated with artworks. This vocabulary can be applied to any artwork, whatever visual form(s) it takes, and includes particular terminology related to line, shape, color, lighting, and **composition**, as well as specific language related to different artistic media (such as painting versus sculpture versus photography). Artists manipulate various visual properties and artistic media to "speak" to their viewers, communicating ideas and sensations

without spoken or written language. As you come to understand the language of visual forms better, you'll certainly find your responses to artworks growing richer. You'll also come to better understand artworks as a highly manipulated, and at times even manipulative, artificial reality. Armed with some tips and techniques to analyze art's visual language, you will be better able to identify and appreciate each of the many different ingredients that artworks blend to convey meaning. These are the topics covered in the next chapter.

3

Analyzing Art

In the previous chapter, we focused on the experiences of looking at art and the different visual approaches that artists use in creating their work. Identifying these approaches is an important part of the process of writing about art, and it is a necessary first step in analyzing the visual properties of art, a process sometimes referred to as **formal analysis**. To conduct formal analysis, however, you'll also want to explore and understand the specific visual properties, media, and techniques that artists use to produce their work—whether their work is representational, abstract, or nonobjective. And, in many cases, formal analysis isn't the only approach you'll use to investigate and write about art. In this chapter, we will briefly describe the various analytical approaches—starting with formal analysis—that serious students of art are asked to employ in their writing.

Formal Analysis

Careful analysis of an artwork's form is an essential skill for any student of art. Nearly every essay about art will employ formal analysis (sometimes also called "visual analysis"), even ones that are written primarily from another perspective.

So what is formal analysis? Formal analysis dissects the complex synthesis of line, shape, color, lighting, texture, composition, materials, and fabrication practices as they are combined and manipulated by artists and craftspeople (sometimes working individually, sometimes in groups). This synthesis seems complex because it is: The meaning of an artwork is expressed through the complicated interplay of its many formal elements. These elements range from matters as straightforward as what color an artist uses to depict a particular element in a scene, to issues as subtle as the arrangement of figures in a scene to signal cultural or political meanings.

While it is certainly possible for the overeager analyst to read more meaning into a specific formal property than the artist(s) intended, you should consider that artists exploit every tool at their disposal. Every element in every artwork exists for a reason. Your task in formal analysis is to examine the intent and effects of each of these elements. You'll want to consider how the parts of an artwork interrelate—how some elements are visually descriptive and seem to replicate the recognizable world, while others may suggest a particular mood or tone in an artwork. In addition, you'll want to

consider how certain formal properties, such as an artwork's composition, are made up of other formal properties, such as line, shape, and color. You'll also want to consider how certain artistic media and materials require certain technical skills, and how these skills contribute to the formal properties of a specific work of art.

DESCRIBING FORMAL PROPERTIES OF ART

Whatever formal element or elements you choose to write about, you need to offer your reader dynamic, detailed, descriptive writing. In other words, you need to *show*, not merely *tell*, your readers what you see. While your essays cannot provide your reader with lifesize images or offer up the tactile properties of a particular material, they can evoke— through language—something of an artwork's form and your experience of it. Also important to note is that a good description can be analytical: The way you *describe* an artwork can convey your *analysis* of that artwork. For these reasons it's important to craft your descriptions with great care.

Let's look at two descriptions of Gustave Courbet's (1819–1877) painting *A Burial at Ornans* (1849–50) (fig. 5, p. 62). In the first example, notice that the writer offers little more than a basic description of the painting:

Courbet's *A Burial at Ornans* portrays a funeral scene set in the French countryside, at a cemetery with a long row of

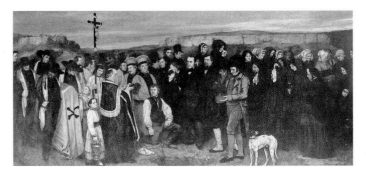

Fig. 5: Gustave Courbet, *A Burial at Ornans*, 1849–50. Oil on canvas, 124⅛ x 263 in. (315 x 668 cm). Musée d'Orsay, Paris.

mourners positioned near an empty grave. In the distance, a pair of cliffs defines and frames the horizon.

This writing doesn't suggest anything very distinctive about Courbet's work. We don't get a sense of the quantity of people that dominate the image; nor do we get a sense of the painting's unusual horizontal composition. Moreover, this passage communicates nothing about the importance of the location (named in the title) in Courbet's conception and depiction of the scene. The passage also fails to connect the description to any type of analysis: The writer describes the scene but doesn't show us the significance of this imagery. In sum, the writer has squandered an opportunity to write a description that also shapes her analysis.

The next example, by the art historian T. J. Clark, is more descriptive. Note that Clark not only practices the principle of

Show, don't tell, but he also shapes his description in order to introduce important analytical points:

> Courbet has gathered the townspeople of Ornans in the new graveyard, opposite the cliffs of Roche du Château and Roche du Mont. He has painted more than forty-five figures life-size in a great frieze over eight yards long, arranging the figures in a long row which curves back slightly round the grave itself; and in places, following the conventions of popular art, he has piled the figures one on top of the other as if they stood on steeply sloping ground. And towards the right of the picture he has let the mass of mourners congeal into a solid wall of black **pigment**, against which the face of the mayor's daughter and the handkerchief which covers his sister Zoë's face register as tenuous, almost tragic interruptions.[3]

Clark's analysis of the painting works both because he helps us to see the painting more vividly, and because he indicates certain significant elements of the artwork via his concrete description of Courbet's imagery.

Whatever formal element or elements you focus on when you analyze an artwork, make sure that you use language that is as vivid and descriptive as possible. Tie the concrete

3 T. J. Clark, *Image of the People: Gustave Courbet and the 1848 Revolution* (London: Thames & Hudson, 1973), 81–82 (emphasis added).

details and your carefully constructed observations to larger themes and ideas as you see fit, but always make sure that the particulars within the artwork back up your points. Getting the details right is the heart and soul of formal analysis.

DOING FORMAL ANALYSIS: A CHECKLIST

As you examine an artwork's formal elements, keep in mind the following questions and considerations. For your convenience, we've crafted this list according to the primary categories of artistic form: line, shape, color, lighting, texture, spatial properties, **emphasis**/hierarchy, and composition. We've also included a list of questions and considerations related to the primary categories of artistic media and materials, with related questions about relevant fabrication techniques. If you are uncertain about the meaning of any of the terms used below, you should consult the glossary at the end of this book or a more comprehensive text, such as Debra J. DeWitte, Ralph M. Larmann, and M. Kathryn Shields's *Gateways to Art: Understanding the Visual Arts.*[4]

In General

When you undertake a formal analysis of an artist's methods, you can begin by considering both the artist's likely intent

4 Debra J. DeWitte, Ralph M. Larmann, and M. Kathryn Shields's *Gateways to Art: Understanding the Visual Arts* (Thames & Hudson, 2018).

and the effect that the artwork has on you as a viewer. Ask yourself some basic questions:

What visual approach does the artwork use—is it representational, abstract, or nonobjective? If the artwork is representational, what does it depict, and how closely does it resemble the recognizable world? If it is abstract, to what degree do its forms reference the recognizable world? If it is nonobjective, what formal properties does it emphasize?

What medium or materials has the artist used to create the artwork? What significance or meaning might these materials contribute to my understanding of the artwork?

How does the artwork make me feel? What formal properties and techniques does the artist use in order to communicate these feelings? Did I have any expectations about the artwork before I looked at it? What were these expectations? Where did they come from? How did they shape my reaction to the artwork?

Are there elements of the artwork that I might not have noticed in my initial viewing? If so, what are they, and what properties or techniques make them initially invisible?

What is the size and scale of the artwork? Is it larger than human scale? Smaller? To what degree? How does the artwork's size contribute to my reaction to it?

What can I learn from the artwork's title? What did
the title suggest to me before I looked at the artwork?
What does it suggest now that I've looked at it? Has my
understanding of the title (or the artwork) changed?

What can I learn from the artwork's date? Does the date
coincide with any significant historical events that
might have impacted the motivation for or production
of the artwork? Does the date of the artwork's creation
impact my understanding of it?

Line

Are there any notable linear elements evident in the
artwork? How would you describe these linear
elements? Are they thick, thin, curved, straight, sharp,
sketchy, or something else?

Are there any patterns in the way that lines are used (e.g.
recurring parallel lines, zigzags, etc.)?

How do these linear elements affect your viewing of the
artwork? Why might the artist have employed these
particular linear elements?

Shape

What types of shapes does the artist use? Are they
geometric or organic? **Symmetrical** or **asymmetrical**?
Do they seem heavy and solid, or lighter and more open?

Has the artist used standard or typical shapes to depict
the objects or figures in the artwork (e.g. circular or

oval forms to depict faces)? Or has the artist used shape in uncommon or unfamiliar ways?

Are there any repeated shapes in the artwork? If so, what are they? Does the artist use shapes to create visual patterns in the artwork?

How do these shapes affect your viewing of the artwork? Why might the artist have used shapes in this way?

Color

What types of color does the artwork use? Warm or cool colors? Bright or muted colors? Naturalistic or nonnaturalistic (**arbitrary**) colors?

Does the artwork employ a limited or wide range of colors?

Does the artwork use a particular color scheme? Does it repeat the use of certain colors?

How does this use of color affect your viewing of the artwork? Why do you think the artist has used color in these ways?

Lighting

Is the scene portrayed in the artwork evenly lit, with clear illumination throughout the image? Or is the scene dramatically lit, with extremes of very bright **highlights** and very dark shadows?

Does the depiction of light and shadow within the artwork make logical sense? In other words, do the

areas of illumination and shadow seem accurate and consistent with the apparent or assumed light source(s)?

If lighting is used to illuminate the artwork (for instance, in the case of many sculptures), does the lighting enhance your perception of the artwork, or does it make some areas of the artwork hard to see?

How does this use of lighting affect your viewing of the artwork?

What do you think the artist (or the gallery or museum) meant to achieve with this approach to lighting?

Texture

What tactile properties does the artwork have? For instance, is it smooth or rough? Soft or hard? Does the artwork combine different textures?

Is the texture a physical property of the artwork, or is the texture an illusion?

Does texture contribute to any feelings that the artwork evokes? If so, in what ways? Why might the artist have used texture in this way?

Space

How are objects depicted in space? For instance, does the artwork overlap forms, use linear perspective, or employ another technique to create spatial properties?

Does the artwork depict space from a particular vantage point, such as a view from above (sometimes called an

"aerial" or "**bird's-eye view**") or a view from below
(sometimes called "**worm's-eye view**")?

Does the artwork physically occupy space? If so, does it
extend vertically (upward) into space, or horizontally
(across) space? Both? Are there other notable ways the
artwork occupies space?

Does the artwork call attention to or employ **negative
space** (such as the "empty" areas, or **voids**, within
two-dimensional imagery or the carved-away spaces
between sculpted forms)?

Does the artwork exaggerate the appearance of spatial
depth, or does it flatten space?

How does this use of space affect your viewing of the
artwork? Why do you think the artist has chosen to
engage with space in this way?

Emphasis/Hierarchy

Is there a particular **focal point** in the artwork that
seems especially important? If so, what formal
properties does the artist use to draw attention to
this focal point?

Are some areas or elements of the artwork **subordinate**
to others? If so, what formal properties does the artist
use to divert attention away from these areas or
elements?

How does this use of emphasis affect your viewing of
the artwork?

What do you think the artist was trying to achieve with this use of emphasis?

Composition

How are the elements of the artwork arranged in relation to one another? How are they arranged in relation to the overall artwork? Is the composition symmetrical and **balanced**, or asymmetrical and irregular?

How does the arrangement of the elements direct the viewer to look at the artwork? Does the arrangement encourage the viewer's eyes to move from left to right? From right to left? Top to bottom? Bottom to top? In a **diagonal** motion? In a circular or spiraling motion?

How does this composition affect your viewing of the artwork?

Why do you think the artist has chosen to compose the artwork in this way?

MEDIA/MATERIALS/FABRICATION TECHNIQUES

In addition to the various formal properties listed above, you might also ask yourself some basic questions about the particular artistic medium an artist has used.

What type(s) of materials did the artist use to create the artwork? What tool(s) did the artist use in working

with these materials? What kinds of technical skills do these materials and tools require? How effectively are these materials, tools, and techniques employed in the artwork?

Does the artwork make use of one material, or several different types of materials? If it uses multiple materials, are they all drawn from the same medium (e.g. a combination of several different types of paint), or from different media (e.g. a combination of painting and photography)?

Is there visible evidence of the tools and techniques the artist used in the artwork? For instance, is there brushwork evident in a painting, or are there carving marks apparent in a sculpture? If so, why do you think the artist left these elements visible?

Has the artist used his or her materials and techniques in more conventional or more experimental ways? Why do you think this is the case?

How and where is the artwork displayed? Is it portable or stationary? Does it require any special lighting, a specific space or location, or a particular device for viewers to see it? What kinds of engagements does the artwork solicit from viewers?

Is the artwork intended for a small or a large audience? For limited or extensive exhibition and circulation? What impact does this have on your experience as a viewer?

Has the artwork been manipulated, repaired, or
otherwise altered from its original form? If so, for what
reasons? What might this tell you about the artwork?

Drawing

What drawing material(s) has the artist used? For
instance: pencil, charcoal, ink, crayon, **pastel**, or a
different material?

Is the drawing produced upon paper, and, if so, what type?

Is the drawing produced upon a different type of surface
material? What type?

Does the drawing appear to be a preparatory sketch or
study for a different artwork? Or is the drawing itself
the finished work of art?

Painting

What type(s) of paint has the artist used? For instance:
encaustic, **fresco**, **tempera**, oil, watercolor, **acrylic**, or
a different material?

Is the painting a portable object, or is it stationary, as with
a wall painting or similar architectural decoration?

What type of surface material is the paint applied to?
Has the surface been prepared with an intermediary
material (e.g. **gesso**), or is the paint applied directly to
an untreated surface?

Does the painting have a smooth or a textured surface? If
it has a textured surface, is this due to the application

of paint, or is it the result of some additional substance or material mixed with the paint?

What tools were used to apply paint? For instance: paintbrushes, a palette knife, or a paint crayon? The artist's hands? Another type of tool?

Can you see the brushstrokes (or other types of marks) that the artist has used to apply paint, or are they invisible? If you can see them, do they appear to have been applied with a light or a heavy touch? Do they seem careful and precise, or loose and sketchy?

Sculpture

What sculpture material(s) has the artist used? For instance: wood, stone, **ceramic**, metal, glass, plastic, textile, or **found object**?

What general type of fabrication technique has the artist used? For instance: carving, casting, or construction or other assembly? Is the fabrication technique **subtractive** (meaning materials are removed, as in wood or stone carving)? Or is it **additive** (meaning materials are combined and attached together, as in construction and assemblage practices)?

Is the sculpture a sculpture in the round? If so, is it freestanding, or does it require some kind of physical support? Does it sit on a **pedestal**?

Is the sculpture a relief carving? If so, is it **high**, **low**, or **sunken relief**?

Does the sculpture have more or less **mass**? In other
words, does it seem solid or heavy, or is it lighter and
more open in its forms?

Is the sculpture displayed indoors or outdoors? Is it
site-specific?

Is the sculpture painted or otherwise decorated? Or are its
colors only those of the materials used?

Printmaking

What printmaking technique(s) has the artist used?
For instance: woodcut, linocut, **engraving**, **etching**,
lithography, **silkscreening**, or a different technique?

Is it a single- or multicolor print?

Are there any technical problems apparent in the print?
For instance, if it is a multicolor print, do the
different colors line up accurately with the forms
they depict?

What is the function of the print? For instance, is it
primarily meant as an artwork, or does it have some
kind of commercial or other function?

Was the print in wide or limited circulation?

Photography

What photographic process(es) has the artist used?
For instance: a daguerreotype, **gelatin-silver
photograph**, **cyanotype**, **chromogenic print**,
or digital photograph?

Is it black-and-white or color? If it is color, is it **hand-tinted**, or is it a color photograph?

Is it printed on paper or another type of material? Or is it a digital image viewed on a screen?

Is the photographic image crisply focused or **soft focus** and blurry? Is it a high- or low-resolution image?

Is the image closely **cropped** or a wide-angle view?

Has the photograph been retouched or otherwise manipulated in some way?

Film/Video

Is the artwork produced in **analog** or digital format?

If the artwork is analog film or video, what type? For instance: 16mm, 35mm, or 70mm film; Betamax, VHS, or Hi8 video?

If the artwork is digital film or video, does it have any notable technical specifications (e.g. in relation to its digital file type, delivery platform, or other features)?

Has the film or video been manipulated in some way?

What type of viewing device is used? For instance, is the artwork projected onto a screen? If so, via what type of device, and on what size screen? Or is the artwork viewed on a monitor? If so, what type and size? And does the artwork require more than one screen, monitor, or other device to be viewed?

Does the film or video include a sound component? If so, what type? Music? Voiceover? Spoken dialogue? Something else?

Performance Art/Experimental Theater

What is the setting/location for the performance?

Who is the performer (the artist[s], actor[s], or the audience)? Or does the artwork involve a combination of performers?

Does the performance involve specialized movements or familiar, everyday activities?

Is there dialogue, music, or another sound element in the performance?

What kind of clothing or costume is worn by the performer(s)?

Graphic Design

Is the artwork focused on a particular element of **graphic design**? For instance: **typography**, **logo** development, a brand or rebranding campaign? And what form does the design take? For instance: book, poster, package, product, website, or mobile application design? Some combination of these forms?

Is the design project developed using primarily hand-based techniques or digital rendering processes?

For the text component(s) of the design project, what **typeface**(s) or font(s) has the designer used?

If the design project also incorporates images, what
type(s) of imagery has the designer used?

Are there any **motion**-based elements of the design
project?

Is the design project print-based, or screen- and/or
web-based? A combination of these formats? Some
other format?

What type of client solicited the design project? For
instance: a corporation or other large-scale commercial
client? A small business or other small-scale
commercial client? A nonprofit or government agency?
A private individual? Or did the designer create the
project independently, without a client?

Mixed Media

What different artistic media and/or materials does the
artwork combine?

Does the artwork use primarily traditional artistic
materials (e.g. oil or acrylic paint, carved wood or
stone, cast metal, etc.)? Or does the artwork incorporate
other types of materials or objects (e.g. industrial
paints, cast plastics, commodity objects, etc.)?

Based on the types of materials used, what kinds of
artistic techniques would have been involved in
producing the artwork? (To develop an answer to this
question, you might review the questions related to
different media indicated above, as appropriate.)

Architecture

What construction technique is used? For instance: **post-and lintel**, **corbeling**, **vault**, **arch**, **dome**, or another technique? A combination of techniques?

What types of materials are used in construction? For instance: wood-frame, masonry, iron, steel, **concrete**, or another type of material? A combination of materials?

What is the function of the building? For instance, it is a religious or a secular structure? Does it have multiple functions?

How does the building relate to its setting, location, and/or environment?

What is the scale of the building?

Interlude: Exploring Meaning

CONSIDERING CONTENT

During your initial observations of an artwork, you may develop your formal analysis separately from your exploration of its content. To understand an artwork fully, however, you must also consider its content. As we noted in a previous chapter, some artworks are representational, inviting you to consider (or to reconsider) images and subjects that are familiar. Other artworks are abstract, with content that can be more difficult to discern (though occasionally a title might help). And other artworks are nonobjective, meaning

they lack conventional types of (and approaches to) content and instead urge the viewer to consider a new approach to artistic practice or an alternative way of thinking about the world. No matter what type of artwork you are looking at, it's important to note its content, which will help you assess that content's deeper meaning and purpose.

For instance, one of the most common—and established— types of artistic content is **narrative**, meaning artworks that use imagery to tell a story or recount an event. Narrative artworks frequently adopt content from existing sources, such as history, religion, or literature. If we are familiar with an artwork's source, we can often identify its content very quickly. But narrative artworks typically do more than translate an existing story or past event into pictorial form; they also carry social or cultural meanings, again drawn from their sources and often linked to their historical contexts.

Portraiture is another extremely familiar type of artistic content. **Portraits** are generally understood to be artworks that record the physical appearance of an individual, a couple, or a group of people. Like narrative artworks, portraits also have additional meanings. For instance, they might signal the historical accomplishments and/or the socioeconomic status of their subjects. Similarly, artworks that use landscape as their content often do so not simply to document the appearance of a particular geographic location or terrain, but to communicate meanings associated with national,

regional, or ethnic identities. Landscape content can also communicate social attitudes or cultural philosophies about the natural world.

Other types of content that portray a wide range of meanings include **genre** scenes, which portray moments from private life; still-life imagery, which depicts inanimate objects grouped together; architectural interiors, which record the structural features of buildings; and **animal imagery**, which uses animals (instead of people, landscapes, and the like) to communicate visual messages. Sometimes, artworks combine different types of artistic content. For instance, a narrative scene might use a carefully rendered landscape as its setting, or a portrait might include a still life in its composition. Whatever the content, an artwork's subject matter almost always contributes directly to its meanings.

What is more, a narrative artwork or landscape scene might evoke a particular emotion for its viewers. Moreover, the art might have evoked different feelings when it was first exhibited than it evokes when viewed today. As a result, you may need to consider additional information (such as the title, other examples of an artist's work, or a history of its critical reception) in order to determine an artwork's primary or intended content. Above all, it is important to remember that the content of an artwork can be, and often is, just as complex as its formal properties.

To help you identify an artwork's content and determine its meanings, consider the following questions:

Does the artwork offer a narrative? If so, what is
its source?

Is the narrative source from the same time period as the
artwork itself? Does the narrative come from an earlier
time period? Or does it imagine a future time period?

What particular moment or element of the narrative
has the artist chosen to depict? An early moment in a
narrative? The conclusion? Something from the middle
of the story?

Is the narrative source associated with any known
meanings or messages? For instance, does the source
have a particular social or cultural significance already
associated with it? Is there some kind of established
moral linked to the story?

If the artwork is not narrative, does it fall into some
other category of artistic content? For instance, is the
artwork a portrait? A landscape scene? A still life? Does
it document a particular location or event?

Does the artwork lack conventional content altogether?
If so, does it have some other focus or purpose, such as
the expression of emotion(s)?

THE RELATIONSHIPS BETWEEN FORM
AND CONTENT

As you delve deeper into your analysis, you will come to see
that the form and content of an artwork go hand in hand.

Indeed, for some artworks—particularly nonobjective artworks—the form *is* the content. If you take time to examine the ways that form and content operate together to create meaning, you will find a wealth of interesting ideas that might serve as the foundation for your paper. The relationships between form and content therefore merit further discussion.

These terms—*form* and *content*—crop up in almost any scholarly discussion of the arts. But why are they so often paired? At the most basic level, if we understand content as the *subject* of an artwork (what the work is "about"), then form is the *means* by which that subject is expressed and experienced.

Form, however, doesn't just allow us to *see* the subject or content; it lets us see that content *in a particular way*. Form enables the artist to shape both our experience and our **interpretation** of that content. As we try to understand how the artwork *functions*, we thus become more aware of how form and content interplay to make *meaning*.

Complicating the matter further is that an artwork's content is not determined only by the stories it tells; there are also cultural values, shared ideals, and other ideas that lie just below the surface of art, contributing to its content. All of these cultural elements, as well as the particular form they take, create various layers of meaning in art. These layers of meaning intersect with and inform one another. The notion that any artwork contains layers upon layers of meaning may make the process of looking at art seem intimidating. But you'll find that the process of observing, identifying, and

interpreting the meanings of art will become considerably less mysterious once you grow accustomed to looking actively at artworks rather than just glancing at them. It might also help to keep in mind that, no matter how many different layers of meaning there may be in an artwork, each layer is either *explicit* or *implicit*.

EXPLICIT AND IMPLICIT MEANING

Explicit meanings are those that an artwork makes immediately apparent to its viewers. For instance, the central facts of a story, depicted in a representational or abstract artwork, are explicit. In contrast, implicit meanings are seldom clearly evident and are closest to our everyday sense of the word *meaning*. In this sense, implicit meanings include associations, connections, or inferences that a viewer makes on the basis of explicit properties or other details that are immediately apparent when one looks at an artwork.

To tease out the difference between these two levels of meaning, let's look at two statements about Jean-Honoré Fragonard's (1732–1806) painting *The Swing* (c. 1767–68) (fig. 6, p. 84). First, let's imagine that a friend has recently come across an image of the painting and is curious about what she's seen. Your friend knows that you are taking an art history class and asks you to tell her what Fragonard's artwork is about. She doesn't want an in-depth historical analysis. Instead, she wants you to provide her with an intelligent

Fig. 6: Jean-Honoré Fragonard, *The Swing, c.* 1767–68. Oil on canvas, 32 x 25³⁄₈ in. (81 x 64.2 cm). Wallace Collection, London.

overview of the artwork's form and content, to give her a sense of whether or not she might want to explore the painting further or look at other examples of Fragonard's work. In other words, she is asking for a statement about the explicit meaning of the painting. You might respond to her question by explaining: "Fragonard's painting depicts aristocrats enjoying lives of leisure and luxury in a lush garden. Painted in the eighteenth century, *The Swing* displays the pastel colors and delicate brushwork characteristic of the French Rococo style, which celebrated the wealth, elegance, and frivolity of the aristocracy in France at the time."

Now what if our friend hears this statement of explicit meaning and asks, "Okay, sure, but what do you think the painting is trying to say? What does it *mean?*" In a case like this, when someone is asking about the meaning of an artwork, he or she is seeking the artwork's deeper message or "point." In essence, our friend is asking us to *interpret* the artwork—to say something arguable about it—not simply to provide a general or introductory overview about the artwork's content and style that everyone can agree on. In other words, she is asking us for our sense of the artwork's implicit meaning. One possible response might be: "In *The Swing,* a young aristocratic woman enjoys a tryst with her lover while an older man—likely her fiancé or husband—pushes her on an outdoor swing. Fragonard indicates that the image depicts an illicit or extramarital affair because the younger man, positioned underneath the young woman, appears to

be hidden from the older man by the lush foliage, and his vantage point allows him to look up the young woman's frothy skirts. Also, the young woman has kicked off her shoe, an act that, in eighteenth-century French culture, typically symbolized a loss of innocence."

At first glance, this statement might seem to have key points in common with our summary of the painting's explicit meaning—as, of course, it does. After all, even though a meaning is under the surface, it nonetheless has to relate to the surface. Our interpretation of the artwork's implicit meaning therefore needs to be grounded in the surface's explicitly presented details. Nevertheless, if you compare the two statements about *The Swing* closely, you can see that the second is more interpretive than the first—more concerned with what Fragonard's painting "means."

Explicit and implicit meanings need not pertain to an artwork or an artistic style as a whole, and not all implicit meaning is tied to broad messages or themes. Smaller doses of both kinds of meaning are often present in different areas or components of an artwork. For example, there are two sculptures in the garden setting of *The Swing*, including one that depicts Cupid (on the left of the painting, facing the young woman). Such a sculpture would have been commonplace in the grand gardens of aristocratic estates in the eighteenth century, and Cupid was a popular figure in French Rococo art. In this particular artwork, however, the Cupid figure holds his finger up to his lips, and this shushing gesture

serves to symbolize a secret—likely the illicit nature of the relationship between the young man and woman. Similarly, in the lower right corner of Fragonard's painting (just in front of the older man hidden in the shadows), a small dog barks at the young woman. In terms of its explicit meaning, the dog does not seem out of place in the garden setting. But in terms of implicit meaning, dogs have historically been used in Western art as symbols of fidelity. With this in mind, the barking dog seems to be another indication of (and perhaps a warning against) the extramarital affair between the two young people depicted in *The Swing*. In addition, the dog in this painting is a lapdog, which had even more specific symbolic meanings in eighteenth-century French culture and which might, in turn, expand the implicit meanings to be found in Fragonard's artwork.[5]

CULTURAL ATTITUDES AND IDEALS

In analyzing art, we need to take into account not only our own beliefs, but also the cultural attitudes and ideals that typically inform artistic developments—the attitudes of the artist(s), **patron(s)**, and audience(s) associated with an artwork's original production and exhibition. While artists generally create

5 On these and related points in Fragonard's painting, see, for instance, Jennifer Milam, "Playful Constructions and Fragonard's Swinging Scenes," *Eighteenth-Century Studies 33*, 4 (Summer 2000): 543–59.

work that reflects their attitudes about a subject or theme, many have worked to please their patrons. Their work therefore frequently also displays the cultural attitudes and ideals of the people who funded its creation. Similarly, due to the pressures of commercial, market-driven forces, artists might align their work with commonly held attitudes and beliefs in order to appeal to the largest possible audience.

Whatever the case, when we view and analyze artworks created in time periods or cultural traditions different from our own, we often confront attitudes and ideals that can vary widely from those that we are most familiar—and comfortable—with. For instance, an artwork made in certain Western locations during the eighteenth century may reflect Western cultural attitudes that assumed the ownership of people as slaves to be legally and morally permissible, while today such a practice is both illegal and unethical. Artworks from different cultural traditions also frequently exhibit religious attitudes and beliefs different from those we find in our own culture (whether or not we subscribe to such beliefs). These kinds of discrepancies may lead us to interpret the meanings of artworks differently than would have been the case at an earlier moment or in a different culture. While these alternative interpretations can be, and often are, both valid and important, we need to acknowledge, when engaging in these kinds of analyses, the historically and culturally specific attitudes associated with an artwork or style. Otherwise, our insights can come across as unaware of the complexities of historical change and cultural diversity.

Finally, while some artworks make their cultural attitudes immediately apparent, other artworks contain attitudes that are more subtle or even hidden (similar to the explicit and implicit meanings of art). In some cases, artworks showcase cultural attitudes or beliefs that artists did not intend to address. Thus, when interpreting artworks, you will want to be on the lookout for not only themes and attitudes that artists have consciously incorporated into their work, but also those that may have unexpectedly found their way into the work. This can be liberating for you as you write about art: You are not limited to deciphering the artist's intent but can explore the unintended messages, along with the effects that art has on its audiences across different eras and cultures. Having taken this time to explain what we mean when we talk about "meaning," we can now turn to the next general approach to analyzing artworks: *cultural analysis*.

Cultural Analysis

Art historians and critics not only look at the visibly evident properties of art to understand what it means; they also examine the layers of implicit meaning that reflect any cultural assumptions or attitudes that artists and viewers might take for granted.[6]

6 For more in-depth discussion of different approaches to cultural analysis in art history, see Anne D'Alleva, *Methods and Theories of Art History* (London: Laurence King, 2012).

The tools that scholars use to analyze art in this manner are borrowed from critical theories first developed by philosophers, social theorists, and cultural critics. While these perspectives are "tools of the trade" for professional scholars and critics, they can prove challenging to students who are just beginning their studies. You needn't feel pressured to master art theory and criticism before writing your paper. Even a basic understanding of the theoretical perspectives commonly used by scholars can be useful to novice writers. First, these theories can show you how to cast a more analytical eye on the unspoken assumptions and ideals that seem to be taken for granted in the artworks you write about. Second, these theories can be used to jumpstart a paper by giving you different frameworks through which to view art.

The most important theoretical frameworks in art history, theory, and criticism include *Marxism, feminism, critical race and postcolonial theory,* and *queer theory.* When applied to art, these perspectives offer a critical lens through which you can examine an artwork's portrayal of socioeconomic status (Marxism); gender (feminism); race, ethnicity, or national origin (critical race and postcolonial theory); and sexual orientation and identity (queer theory). Let's look at each of these categories to see how they might serve your analyses of art.

SOCIOECONOMIC STATUS

Regardless of certain commonly held assumptions that art is intrinsically free from political and economic concerns,

artworks cannot avoid issues of socioeconomic status. Artists operate within particular socioeconomic conditions, and artworks exist within networks of socioeconomic value and exchange. That is to say, depending on various historical and political factors, artists may have been held in high esteem and may have been well compensated for their efforts, or they may have worked in obscurity and for relatively little financial or other economic gain. The social and economic value of artworks also fluctuates over time.

Throughout history, many artworks have explicitly depicted people from different social classes as well as the complex social and economic conditions in which people lived. Other artworks evoke these matters in more subtle or implicit ways. In either case, artworks may portray a social class negatively, positively, or anywhere in between, thereby offering messages about the rightness (or wrongness) of socioeconomic hierarchies. Some artists may seem willfully blind to socioeconomic and political tensions that exist in their historical moments, while others may seem keenly attuned to such matters.

The theoretical perspective that is most commonly used to analyze issues of socioeconomic class in art is Marxist art history (sometimes also called *materialist art history*). This framework focuses on the ways that artworks either reinforce or undermine the dominant socioeconomic power structures in a society. Based on the extensive philosophical and economic writings of Karl Marx (1818–1883), this type of analysis

sees artworks not as isolated from their social, economic, and political conditions, but rather as an important means by which the socioeconomic and political status quo is either maintained (most of the time) or disrupted (occasionally).

Marx himself saw the arts (along with law, religion, and other institutions) as part of the **superstructure** of society—an overlay of ideologies that reflects the perspective of those at the highest levels of power. According to Marx, some art forms (especially those found in popular culture, which is sometimes called **kitsch**) lure the working classes and the poor to rally around ideas that perpetuate the power of those at the very top of the social ladder. When there is broad consensus among the working classes and the poor that the status quo, while unfair to them, is inevitable and proper, then they are exhibiting, to use Marx's phrase, "false consciousness." The very values they subscribe to are working directly against their socioeconomic interests. In Marx's view, popular culture is one of the means by which the powerful lure the poor and working classes to embrace false consciousness and to internalize the dominant culture's values and ideas.

The art forms that are frequently the focus of art and art history courses—in particular, the so-called "high" or "fine" art of such media as painting and sculpture—have historically been linked to socioeconomic power and privilege. These art forms have typically been funded (or otherwise supported) by wealthy elites, which means that such art is also often aligned with the socioeconomic status quo. For

many Marxist art historians and critics, this art serves as important evidence of dominant power structures found in various historical moments.

In contrast, a number of Marxist cultural theorists and critics have argued that some types of art counteract false consciousness and intervene in the status quo. For instance, according to some Marxist art historians and critics, certain examples of **avant-garde** art stand in opposition to kitsch. In some cases, this work displays content that invokes revolutionary possibilities. In addition, for some Marxist scholars, the radical formal and technical experiments found in avant-garde art call forth new modes of human perception that may also lead to social and political change. For others, however, these formal experiments are nothing more than a further example of elitism in "high" or "fine" art.

From a Marxist perspective, any work of art may work against some aspects of the dominant power structure even as it reinforces others. There is always the potential for artworks to break free of dominant narratives and introduce perspectives that inspire us to see "the way things are" with fresh eyes. However, it is also important to remember that even radical examples of avant-garde art frequently become subject to dominant socioeconomic forces (for instance, as soon as they enter systems of patronage and ownership). Indeed, according to Marxist theories, the very powerful pull of one's social milieu prevents even the most radical artist from breaking entirely free from accepted ideas and expressions.

Following Marxist thinking, many art historians and critics examine art to uncover its unspoken ideas about power and socioeconomic class. Marxist analyses examine the ways that social classes are represented in artworks, as well as what messages art seems to send about each class and its place in existing socioeconomic hierarchies. When looking at artworks that set out specifically to undercut dominant ideologies, Marxist analyses examine both the ways that art succeeds in doing so and the ways that it inadvertently reinforces existing social structures.

If you are interested in considering issues of socioeconomic status as a springboard for your analysis, you might ask the following questions:

What kinds of imagery and/or messages does the artwork provide about socioeconomic status? What cultural attitudes about socioeconomic status are apparent (either explicitly or implicitly) in the artwork?

Is a particular socioeconomic class portrayed in the artwork? If so, how is that class portrayed (e.g. positively or negatively), and what seems to be the point of that portrayal?

Does the artwork reinforce or challenge the socioeconomic status quo that prevailed in the time and place it was made? How so?

What is or was the socioeconomic status of the artist? How might this status have played a role in the artwork?

What is or was the socioeconomic status of the patron?
How might this status have played a role in the
creation of the artist's work?
How did artists make a living in a particular time period?
What systems of patronage or markets were in place?
Were there other opportunities for economic support,
and if so, what kinds? And what impact do these
various economic forces appear to have had on artistic
developments at the time?

GENDER

Like socioeconomic status, gender plays an integral role
in art. In fact, gender has shaped most artworks in some
way—whether by gender privilege and hierarchies that have
historically enabled some (usually male) artists to pursue
more professional opportunities than other (usually female)
artists; or by sexist **stereotypes** that may be apparent in (or
may be excised from) artistic content; or by the materials and
techniques that an artist might be encouraged or expected
to use, due to their conventional associations with one set of
gender stereotypes versus another.

The theoretical lens through which these issues are ana-
lyzed is *feminism* (or *gender studies*). Feminist art history
and theory bring to the study of art the same overall con-
cerns that mark the feminist movement as a whole: namely,
a desire for gender equality in both society and the arts; a

critical examination of the roles that women have traditionally been expected to fulfill in society and the arts; and a critical perspective on representations of gender that reinforce stereotypes and that make the status quo of gender inequities seem "natural" and inevitable. In addition, some feminist art historians employ *intersectional* analyses in their work, meaning they explore the ways that gender interacts with socioeconomic status, race, sexuality, and related systems of power to create highly varied and complex conditions—and experiences—of privilege and oppression in both the visual arts and the world overall.

Initially, feminist art historians and critics focused on two particular areas of inquiry: first, investigating women artists and their achievements throughout art history; and second, examining various gender stereotypes found throughout representations of women (and men) in the visual arts. The first area of inquiry was a response to widespread assumptions in art history and criticism (especially since the nineteenth century) that there were no women artists worthy of serious scholarly or critical attention. One of the earliest published challenges to these claims is Linda Nochlin's landmark essay "Why Have There Been No Great Women Artists?"[7] Here, Nochlin traces the social forces, cultural attitudes, and

7 Linda Nochlin, "Why Have There Been No Great Women Artists?," in *Women, Art, and Power and Other Essays* (New York: Harper & Row, 1988 [1971]), 145–78.

institutional parameters that historically made it difficult—though not impossible—for women to pursue professional training and careers in the visual arts. At the same time, many feminist authors devote their attention to studying and writing about the accomplishments of women artists whose successes have been buried or disavowed in much art historical scholarship and art criticism. These efforts are designed to recover the otherwise missing histories of women artists and to create revised accounts of art history and criticism that showcase these women and their achievements.

In the second area of inquiry, many feminist art historians and critics have identified numerous female figure "types" that recur in art history, particularly in Western art. Through detailed visual and historical analyses, authors have demonstrated the ways that these images have been linked to sexist assumptions about women's social roles, their intellectual and physical capacities, and their spheres of activity and influence. In addition, many feminist art historians and critics have borrowed a key concept from feminist film theory—the male "**gaze**"—to interrogate the ways that women are frequently depicted as passive objects of male desire.[8] As feminist scholars have noted, such images assume that the viewers looking at them are heterosexual men, regardless of a viewer's actual

8 On the male gaze, see for instance Laura Mulvey, "Visual Pleasure and Narrative Cinema," in *Visual and Other Pleasures* (Bloomington and Indianapolis: Indiana University Press, 1989 [1975]), 14–26.

gender identity or sexual orientation. Thus, artworks depicting female figures have historically adhered to patriarchal notions of women, creating imagery and meanings that are designed to serve the power structures of male domination.

There are many female figure "types" in Western art that visualize and reinforce sexist stereotypes, including the angelic virgin, the serene mother, and the seductive temptress (sometimes called the femme fatale). In many instances, these image "types" are linked to iconic mythological and religious figures, such as the Greco-Roman goddess Venus (also known as Aphrodite) and the Judeo-Christian figures of the Virgin Mary and Mary Magdalene. In the visual arts, however, arguably no image is more blatant—or pervasive—in its gender stereotypes than the female **nude**. Indeed, while the female nude as an image "type" has its own complex history and exists in many variants throughout Western art, for feminist art historians and critics, many examples of the female nude invoke sexist stereotypes. Specifically, many feminist scholars have argued that the female nude projects a notion of women as objects, rather than as fully realized human beings, defined primarily (if not exclusively) in relation to idealized beauty and conventional—which is also to say heterosexual—sex appeal.

Because of the work of feminist art historians and critics since the late 1960s and 1970s, far more attention has been paid to women's artistic accomplishments, not only in the historically male-dominated media and techniques of drawing,

painting, sculpture, and printmaking (among others), but also in those materials and practices stereotypically linked to (and thus often devalued as) "women's work," such as sewing or **embroidery**. In addition, feminist art historians and critics have focused on the work of women artists, both past and present, that reconfigures images of women in visual art. With these and related efforts, feminist authors advocate on behalf of artists and artworks that are more nuanced—and accurate—in their portrayals of gender.

If you are interested in investigating how gender plays out in art and art history, here are a few questions you can ask yourself to jumpstart your thinking:

What kinds of imagery and/or messages does the artwork provide about gender? What cultural attitudes about gender are apparent (either explicitly or implicitly) in the artwork?

Does the artwork reinforce or challenge assumptions about gender roles that prevailed in the time and place it was made? How so?

Does the artwork depict a woman or women, and, if so, does it use any female figure "types" or sexist stereotypes in its imagery? If so, which one(s)?

Does the artwork seem to suggest that the relations between the sexes are "natural" and proper, or does it seem to critique the status quo? If the latter, what is the nature of the critique?

What is or was the artist's gender? How might this have
played a role in his/her work?

What is or was the patron's gender? How might this have
played a role in the creation of the artist's work?

Does the artwork use materials or techniques that
are associated with stereotypic gender roles (e.g.
sewing, embroidery, weaving, knitting)? If so, are
these materials and techniques meant to reinforce or
challenge these stereotypic associations? How so?

RACE, ETHNICITY, AND NATIONAL ORIGIN

Today, art history and criticism are routinely used to analyze
art and **artifacts** from cultural traditions found around the
world. However, this has not always been the case. Because
art history and criticism developed within Western philo-
sophical traditions, they have frequently privileged Western
practices, especially art and artifacts that depict people of
European descent and their perspectives of the world, often
to the detriment—and exclusion—of people and perspectives
from non-Western locations.

In part, Western art and attitudes have dominated art
history and criticism (until recently) due to the impact of
European imperialism and colonialism. Beginning in the
fifteenth and sixteenth centuries, Spain, England, and other
European countries initiated systematic national efforts to
invade, conquer, and in some cases establish settlements in

countries and territories on other continents, including the Americas, Asia, and Africa. Sometimes described as voyages of "discovery," these imperialist efforts were designed not simply to explore locations outside Europe but also to exploit the natural and human resources in these locations for European economic and political gain.

Of course, human history offers many examples of colonialism, including invasion and conquest by non-Western nations and cultures. But European imperialism and colonialism since the fifteenth century has especially propagated attitudes of Western racial and ethnic superiority used to justify the enslavement and oppression of non-Western peoples. These attitudes historically divided the world into two parts: an (assumed) majority population of European-descent people that benefits from Eurocentric power and prestige (often called *white privilege*); and a wide variety of so-called "minority" populations that are considered to be less "civilized" and human than—and are thus "othered" in relation to—their European counterparts. Above all, colonial visions of the world ignore and delegitimize the identities and perspectives of "minority" populations as a means of asserting the (false) superiority of the West. Such beliefs make it difficult for members of any "minority" or "othered" group to be seen, heard, or treated with respect.

European imperialism and colonialism have had a profound impact on art and culture. For instance, imperialism enabled Western colonial nations to acquire—or, as many

would now say, steal—art and artifacts from colonized people and nations. Indeed, many of these acquired or stolen artworks can be found throughout Western museums. In addition, many of the Eurocentric attitudes that developed in conjunction with imperialism underpin various racist images and stereotypes that continue to circulate in our world today.

Art historians and critics who investigate these issues bring a wide range of theoretical tools to their work. One of the tools these scholars frequently use is *postcolonial theory*, which examines the complex political, economic, and cultural legacies of Western imperialism and colonialism. In addition, critical accounts of race, ethnicity, and national origin in art depend on some familiarity with core concepts in the social sciences and philosophy, as well as a broad understanding of cultural and political history.

For students at the beginning of their studies in art and art history, a sensitivity to racial issues can enrich an analysis of art. Asking pointed questions about racial tensions or imbalances can lead you to observations that will strengthen your analysis. Similarly, paying attention to the profound inequities involved in Western imperialism, and the ways that these inequities have impacted both artistic practice and art history, will enhance your writing about art. Here are a few questions you might ask to get yourself started:

What kinds of imagery and/or messages does the
artwork provide about race, ethnicity, and/or national

origin? What cultural attitudes about race, ethnicity, and/or national origin are apparent (either explicitly or implicitly) in the artwork?

Does the artwork reinforce or challenge assumptions about race, ethnicity, and/or national origin that prevailed in the time and place it was made? How so?

Are there any racist stereotypes apparent in the artwork? If so, what are they?

Does the artwork seem to suggest that Eurocentrism and white privilege are "natural" and proper, or does it seem to critique these attitudes? If the latter, what is the nature of this critique?

What, if anything, do you know about the artist's race, ethnicity, or nation of origin, and how might it have played a role in his/her work?

What, if anything, do you know about the patron's race, ethnicity, or nation of origin, and how might it have played a role in the creation of the artist's work?

Given what you know about the time and place in which the artwork was made, are there any groups of people not shown or barely acknowledged in the artwork who were nonetheless significant and visible? Why do you think they aren't made visible?

Does the artwork use any visual cues (color, lighting, composition, etc.) to suggest that a figure or a group of figures is "other"? If so, what are these cues and how do they operate in the artwork?

SEXUAL ORIENTATION AND IDENTITY

When it comes to human sexuality, what is "normal"? What is non-normative? These categories are of great interest to many people. Public attitudes about the boundaries between the various categories of sexual practice are always in flux. In spite of this constant flux, cultural attitudes about sexual activity and identity typically involve tensions around what constitutes acceptable versus unacceptable behaviors. Historically, such attitudes have tended to support the idea that heterosexuality is the norm, with any other sexual activities or identities considered transgressive. These attitudes, often described as *heteronormativity*, both privilege and naturalize heterosexuality, rendering any different expressions of sexuality "abnormal" or "other." Similar to the "othering" of people in relation to race, ethnicity, and national origin, heteronormative attitudes make it difficult for people who identify as gay, lesbian, bisexual, transgender, or otherwise queer to be respectfully acknowledged and taken seriously.

Scholars who examine these issues in the visual arts use a broad array of theoretical tools to conduct their analyses, including the approach known as *queer theory*. Art historians and critics who use queer theory as an analytic framework typically pursue several different kinds of projects. Similar to the efforts of feminist authors, some of these scholars work to recover unknown or disavowed histories of artists who were

gay, lesbian, bisexual, transgender, or otherwise outside the societally defined "norms" of sexual identity. Many of these artists intentionally kept this aspect of their identity under wraps, so these recovery projects can be especially challenging. Such projects can also involve complex ethical questions about "outing" people who kept their sexuality hidden. What is more, many of our current notions of sexual identity are themselves relatively recent, Western developments that most scholars date to the nineteenth century. As a result, how we understand sexual activity and its role in a person's sense of self also needs to account for historical changes and culturally diverse approaches to sexual orientation and identity.

In addition, some art historians and critics who use queer theory focus their attention on artistic portrayals of sexual orientation and activity. For instance, some scholars are concerned with the various ways that artworks convey heteronormative messages. These critics often use queer theory to identify and critique omissions, distortions, and stereotypes of non-normative sexual identities wherever and whenever they appear. Sometimes, these scholars also investigate drag, camp, cross-dressing, and related phenomena, chiefly because these phenomena shine a spotlight on the ways that sexual identities are shaped by "performative" engagements, which makes them easy to reconfigure and undermine. In particular, as Judith Butler and other queer theorists have argued, these non-normative phenomena suggest that even the most normative presentations of sexuality are similarly

performative and are thus equally unstable.[9] In other words, queer theory suggests that sexual identity—and, in turn, identity more generally—is less secure and predictable than we commonly assume it to be. With these ideas in mind, some art historians and critics explore artworks that directly challenge standard or stable notions of sexuality.

If you're interested in analyzing artworks through the lens of sexual orientation and identity, you might begin by asking the following questions:

What kinds of imagery and/or messages does the artwork provide about sexual activity and sexual orientation? What cultural attitudes or ideals about sexuality are apparent (either explicitly or implicitly) in the artwork?

Does the artwork reinforce or challenge assumptions about sexuality that prevailed in the time and place it was made? How so?

Are there any homophobic or heterosexist stereotypes apparent in the artwork? If so, what are they?

Does the artwork seem to suggest that heteronormativity is "natural" and proper, or does it seem to critique heteronormativity? If the latter, what is the nature of this critique?

9 See, for instance, Judith Butler, "Imitation and Gender Insubordination," in *Inside/Out: Lesbian Theories, Gay Theories,* ed. Diana Fuss (New York and London: Routledge, 1991), 13–31.

What, if anything, do you know about the artist's sexuality, and how might it have played a role?

What, if anything, do you know about the patron's sexuality, and how might it have played a role in the creation of the artist's work?

Does the artwork use any visual cues (color, lighting, composition, etc.) to suggest that a figure or a group of figures is "other"? If so, what are these cues and how do they operate in the artwork?

What function, if any, do performative aspects of sexuality have in the artwork? Are there drag elements? Camp? Cross-dressing? What role do such elements play in the artwork? How do these elements contribute to our understandings of sexuality?

Historical Analysis

Over the long history of artistic practices across cultures, art has developed its own distinctive, if also wide-ranging, conventions, influences, and, of course, histories. As we practice them today, art history and criticism can be traced to the eighteenth century, with precursors dating back to the sixteenth century. Broadly defined, art history traces the development of visual forms and practices from the earliest known surviving examples of art in the Paleolithic era (meaning artifacts from between approximately forty thousand and ten thousand years ago) to artworks created in the present day.

To get some idea of the scope and depth of the art historical record, you might browse through a comprehensive art history survey textbook. These comprehensive histories take many years, and often the efforts of many people, to get written. They are frequently updated to account for new discoveries and developments in the visual arts, as well as changing approaches in art history and criticism. Because of this, most art historians don't undertake such massive projects. Most people who practice art history instead focus their energies on studying specific artworks, artists, styles, movements, media, and historical moments, among other phenomena. For instance, in *L'Amour fou: Photography and Surrealism*, authors Rosalind Krauss, Jane Livingston, and Dawn Ades explore the ways that the formal and technical properties of photography were used between the 1920s and the 1940s in the service of the visual and **conceptual** goals of Surrealism.[10] Charmaine A. Nelson's *The Color of Stone: Sculpting the Black Female Subject in Nineteenth-Century America* demonstrates the ways that, during the nineteenth century, Neoclassical sculpture in the United States both deployed and reinforced an intricate web of Eurocentric and patriarchal attitudes about race, gender, color, and beauty that rendered African American women—both their images and

10 Rosalind Krauss, Jane Livingston, and Dawn Ades, *L'Amour fou: Photography and Surrealism* (Washington, D.C.: The Corcoran Gallery of Art; and New York: Abbeville Press, 1985).

their experiences—invisible.[11] In these studies and others like them, the authors are interested equally in change—those developments that have altered the course of art's history—and stability—those aspects of art and its history that have defied change.

Like other historians, art historians use artifacts to study the past. Obviously, the most important artifacts to art historians are artworks themselves—the images and objects produced in various artistic media and using a wide array of practices and techniques, as discussed earlier in this chapter. Art historians, however, also examine artist sketchbooks and journals; patronage records; exhibition proposals, catalogs, and, when relevant, photographic documentation; and other sources related to the production, collection, and exhibition of art.

Art history includes the histories of certain technologies; the people and organizations that support and exhibit art; records of the movement of artworks across locations and among different patrons and collections; attempts to suppress and censor art; and the responses and meanings that we derive from viewing art. Gaining knowledge about these and other aspects of art history is interesting in and of itself. But as you graduate from merely glancing at art to viewing art with critical awareness, your knowledge of art history will also provide

11 Charmaine A. Nelson, *The Color of Stone: Sculpting the Black Female Subject in Nineteenth-Century America* (Minneapolis and London: University of Minnesota Press, 2007).

you with the perspective and context to understand and evaluate the unique attributes of artworks, both past and present.

BASIC APPROACHES TO ART HISTORY

Although there are many historical approaches to studying art, the beginner should be familiar with the six most common approaches: formalist, iconographic, biographical, technical, economic, and social. In what follows, we describe each approach and cite at least two studies as models of each.[12]

The Formalist Approach

Not to be confused with formal analysis, the formalist historical approach evaluates artworks, artists, styles, and movements using criteria that assess visual significance and influence, exclusive of any attention to political, social, or economic forces in an artwork's, artist's, or style's context. Ordinarily, writers who take this approach will first define their criteria of artistic excellence and then ask the following questions: What are the most significant works in the visual arts? The most significant styles? Who are the

12 For more in-depth discussion of these and related approaches to historical analysis in art history, see Laurie Schneider Adams, *The Methodologies of Art: An Introduction* (Boulder, CO: Westview Press, 2010) and Michael Hatt and Charlotte Klonk, *Art History: A Critical Introduction to Its Methods* (Manchester and New York: Manchester University Press, 2006).

most significant artists? What are the visual qualities that make these artworks and styles so important? How do certain artists prioritize and exemplify these visual qualities in their work?

Authors who employ a formalist perspective frequently assert that viewing art is a special—and specialized—experience that is solely visual and thus transcends any political, social, or economic forces. In some cases, these authors support the creation and continued validity of an art historical **canon**, meaning an established set of artworks that are held up as the best achievements in the visual arts, as well as the styles and artists associated with these achievements. In formalist approaches, canonical artworks, artists, and styles are the most valued (some might even say revered) throughout art history; canonical artworks are typically also deemed *masterpieces*, and canonical artists have sometimes been described as "Old Masters." Though nearly all art historians use formal analysis in their research and writing, few scholars today subscribe to the ahistorical, decontextualized practice of formalist art history. Earlier authors who used this approach include Roger Fry and Clement Greenberg.[13]

13 For instance, see Roger Fry, *Cézanne: A Study of His Development* (New York: Farrar, Straus & Giroux 1968 [1927]) and Clement Greenberg, "Modernist Painting," in *Clement Greenberg: The Collected Essays and Criticism, Volume 4—Modernism with a Vengeance, 1957–1969,* ed. John O'Brian (Chicago and London: University of Chicago Press, 1993 [1960]), 85–93.

The Iconographic Approach

In iconographic analyses, scholars study the content and meanings that have historically been associated with a particular type of imagery. The word **iconography** literally means "image writing" or "image study." This method of study developed within the discipline of art history. You might think of the iconographic approach as a discipline-specific practice in which scholars identify and decipher the explicit meanings traditionally communicated by the visual language of a specific type of image, such as a still life or landscape, in a specific time period. Indeed, iconographic approaches are deeply rooted in historical context; art historians using iconography understand that certain types of imagery can signal different content and meanings, depending on when

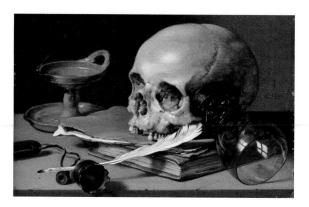

Fig. 7: Pieter Claesz, *Still Life with a Skull and a Writing Quill*, 1628. Oil on wood, 9½ x 14⅛ in. (24.1 x 35.9 cm). Metropolitan Museum of Art, New York.

the imagery was made. For instance, while Christian iconography was extremely common in art produced throughout Europe during the early Christian, Byzantine, medieval, and Renaissance eras, it took many forms and had different, historically specific meanings. Similarly, in the Baroque era, if a still-life painting included imagery of a skull, decaying fruit, or wilting flowers, it typically meant that the artwork addressed a *vanitas* theme, meaning a message about the ephemerality of life and human mortality (see fig. 7).

Typically, scholars using iconography do more than simply identify the content found in a certain type of imagery at a particular historical moment. In addition, they analyze the combination of imagery and content to discern more nuanced messages and meanings. In iconographic studies, this interpretive work is sometimes called **iconology**. Two excellent examples include the collection of essays edited by Elizabeth P. Benson and Gillett G. Griffin, *Maya Iconography*, and Norman Bryson's *Looking at the Overlooked: Four Essays on Still Life Painting*.[14]

The Biographical Approach

Biographical approaches to art history focus on the artist as a key source of information about artworks and art styles. They

14 Elizabeth P. Benson and Gillett G. Griffin, eds., *Maya Iconography* (Princeton, NJ: Princeton University Press, 1988); Norman Bryson, *Looking at the Overlooked: Four Essays on Still Life Painting* (London: Reaktion, 1990).

examine the ways that the events in an artist's life, as well as the artist's psychology, might be evident in his or her work. Biographical approaches are sometimes rooted in the idea that something of the artist's individual personality or spirit is present in each example of the artist's work. As such, art historians who pursue biographical approaches often assume that the artist is the fundamental authority on his or her work. They typically rely upon the artist's statements, journals, and related documents to develop an analysis of the artist's work.

In some cases, biographical approaches to art history veer more toward **biography**, exploring an artist's life more than his or her work. In other cases, these kinds of studies devote far more attention to analyzing artworks than to describing an artist's childhood or hypothesizing about his or her inner life. Above all, biographical approaches to art history review various details about an individual artist as a person in order to explain why that artist's work looks the way it does, or why that artist has chosen to work in a particular medium or with a specific type of content. Such studies tend to be monographs, meaning they study a single artist, as is the case in Christopher White's *Rembrandt* and Barbara J. Bloemink's *The Life and Art of Florine Stettheimer.*[15]

15 Christopher White, *Rembrandt* (London: Thames & Hudson, 1984); Barbara J. Bloemink, *The Life and Art of Florine Stettheimer* (New Haven and London: Yale University Press, 1995).

The Technical Approach

All art forms have technical histories, meaning there have been advancements in materials, devices, and techniques that have affected the nature of various artistic media in different time periods. In addition, throughout art history, new materials, devices, and techniques have been invented. In some instances, artists have borrowed existing materials, devices, and techniques from other fields for their work. Historians who chart the history of artistic technologies, beginning with the earliest time periods, examine the circumstances surrounding the development of each technical change, as well as subsequent modifications and improvements. They pose such questions as: When was the invention made? Under what circumstances—including **aesthetic**, economic, and social—was the invention made? Was it a totally new idea or one linked to existing artistic practices? What were the consequences for artists, patrons, museums and other exhibition venues, markets, and viewers? By studying technical developments, historians show us how the creation of art has changed over time. They also evaluate whether or not technical changes have been substantial and lasting or relatively minor.

Technical approaches in art history also include the field of conservation studies, in which scholars investigate the history of conservation practices over time. These studies include the challenges involved in art conservation and innovations in conservation techniques. In these kinds of projects, art historians often work with conservation scientists and other

experts to consider the physical condition of an artwork. In other words, they aim to determine the extent to which an artwork's materials have deteriorated or have remained intact over time. These efforts in technical art history often explore the best ways to care for artworks in various states of repair (or disrepair).

An excellent example of a study that explores the technical history of a particular set of artistic materials (and related implements and practices) is E. J. W. Barber's *Prehistoric Textiles: The Development of Cloth in the Neolithic and Bronze Ages*.[16] An important example of a history of conservation practices is Noémie Étienne's *The Restoration of Paintings in Paris, 1750–1815: Practice, Discourse, Materiality*.[17]

The Economic Approach

Every artwork has an economic history of its own, as well as a place in the economic history of its artist and the historical period and location in which it was produced. Historians interested in this subject help us understand how different patronage systems and art markets developed and operated; how patronage and other support systems adapted to changing

16 E. J. W. Barber, *Prehistoric Textiles: The Development of Cloth in the Neolithic and Bronze Ages* (Princeton, NJ: Princeton University Press, 1991).

17 Noémie Étienne, *The Restoration of Paintings in Paris, 1750–1815: Practice, Discourse, Materiality*, trans. Sharon Grevet (Los Angeles, CA: Getty Conservation Institute, 2017).

historical conditions (political, social, economic, technical); how artworks have been circulated and exhibited; and how particular economic histories have affected art history more generally. Scholars who take an economic approach also trace exhibition and ownership records for individual artworks over time (such histories are also known as **provenance**), often in order to verify the authenticity of an artwork or to confirm the validity of its ownership. These scholars are also sometimes concerned with patterns of art collecting in various locations and time periods; histories and discoveries of forged artworks and other art crimes; the impact of training systems on art values and markets; the ways that conservation practices can increase or decrease artwork values; patterns of market values for different types of art over time; and the roles that museums and related institutions play in patronage and the art market (among other matters). Examples of such studies include Gail Feigenbaum and Inge Reist's edited collection *Provenance: An Alternative History of Art* and Edward J. Sullivan's edited collection *The Americas Revealed: Collecting Colonial and Modern Latin American Art in the United States.*[18]

18 Gail Feigenbaum and Inge Reist, eds., *Provenance: An Alternative History of Art* (Los Angeles, CA: Getty Research Institute, 2012); Edward J. Sullivan, ed., *The Americas Revealed: Collecting Colonial and Modern Latin American Art in the United States* (University Park, PA: Pennsylvania State University Press, in conjunction with the Frick Collection, 2018).

Social Art History

Because society and culture influence art and vice versa, artworks are excellent sources for studying society. Writing about artworks as social history continues to be a major preoccupation of journalists, scholars, and students alike. As the art historian Albert Boime notes, although what is meant by *social art history* has changed over time, in its current practice social art history understands art and artists to be deeply embedded in—even enmeshed with—their social, economic, political, and historical contexts. That is to say, for social art historians, art cannot be understood in isolation from its contexts, and, at the same time, artistic developments of a specific moment and location provide insights about these contexts. Those interested in social art history thus consider to what extent particular artworks, artists, or styles swayed public opinion or effected social change.[19]

While social art history is a somewhat more recent development than formalist, iconographic, and biographical approaches, it is frequently noted for its combination of breadth and depth, which has made it an increasingly widespread approach. Like many other art historians, social art historians are interested not only in artworks, artists, and styles but also in audiences, critics, patrons, museums, and other art institutions, as well as cultural trends and taboos.

19 Albert Boime, "Preface," in *Art in an Age of Revolution, 1750–1800* (Chicago and London: University of Chicago Press, 1987), xix–xxv.

In particular, social art historians also study art criticism (as it appears in venues ranging from popular newspapers to art magazines); publicity materials for exhibitions and related displays of art; attendance records (when they exist) for art exhibitions and similar events; systems of artistic training; shifting tastes in, and for, various types of artistic content; and many other types of data. Overall, social art historians study the complex interaction between art and other social institutions, including government, religion, and labor. A landmark example of social art history is Boime's four-volume study of Western art from the middle of the eighteenth to the end of the nineteenth century.[20] Many museum exhibitions and their catalogs also examine art as social history; one example is *Age of Empire: Art of the Qin and Han Dynasties*.[21]

QUESTIONS TO GENERATE ANALYSIS

Here are some ways that you can make your analyses of artworks—regardless of their primary topic or approach—more historically aware:

20 Albert Boime, *Art in an Age of Revolution, 1750–1800*; *Art in an Age of Bonapartism, 1800–1815*; *Art in an Age of Counterrevolution, 1815–1848*; and *Art in an Age of Civil Struggle, 1848–1871* (Chicago and London: University of Chicago Press, 1987, 1991, 2004, and 2008 respectively).

21 Zhixin Jason Sun, ed., *Age of Empire: Art of the Qin and Han Dynasties* (New York: Metropolitan Museum of Art; and New Haven and London: Yale University Press, 2017).

As you study a particular artwork, artist, style, or movement, learn as much as you can about its historical context: the era in which it was made and/or exhibited; the location of origin; how the artwork reflects that era and location; how the work was financed; its reception by the public and critics alike. Analyze the artwork, artist, style, or movement as closely as you can within this overall context.

Also learn about an artwork's aesthetic context. Was it made as part of a particular style or movement, or does it break from a movement's prevailing formal or technical properties? If it is representative of a movement, how does it measure up against that movement's ideals and achievements?

Learn something about the artist's overall body of work. Is a specific artwork similar to, or different from, other examples of the artist's work? Does the artist's work exemplify a particular stylistic approach? How so? And how might certain stylistic properties be seen in one or more examples of an artist's work? Since you may not have the time or resources to view all of the artist's work, you might compare the artist's best-known artworks with the one(s) you are analyzing.

When a historical event (e.g. the Mongol invasions of China; the Protestant Reformation in Western Europe;

World War I) has impacted or inspired various artistic developments, you have a rich opportunity to analyze these developments in relation to these events. How do different artists respond to and/or interpret an historical event? How do historians interpret the same event?

Has a particular artwork made important innovations in the formal and/or technical properties of visual art? Who was principally responsible for these innovations? Was this a momentary blip in art history, or did it become a permanent element of artistic practice?

The reception of an artwork or artistic style can be as interesting as its form. Was the artwork generally supported by critics and the public at the time it was produced? Or was the artwork controversial or unpopular? Whatever artwork or style you analyze, take some time to familiarize yourself with its reception history. Consider the initial responses and, if they exist, reviews of the artwork. Also consider longer-term critical and popular opinions about the art.

Now that we've looked at the wide-ranging field of art history and criticism and have discussed the various tools and concerns that scholars bring to their own writing about art, let's look at the process of writing academic papers in art and art history courses. The following chapters will offer you good advice that you can use not only in your art and art history courses, but also in many of your other classes.

As you read about and practice the following strategies, pay attention to which function best for you, and which might become strategies that you can use more broadly in all of your writing.

4

Generating Ideas

In some ways writing about art is similar to writing on any subject: You choose a topic, generate ideas, research your topic, craft a thesis, structure your argument, and find the proper tone. But each of these more general tasks requires you to perform some tasks that are specific to the study of art. For instance, you must look at artworks with a critical and analytical eye (which the preceding three chapters will help you do); you must use specialized language appropriately; and you must know how to use research resources effectively. The following section combines general advice with suggestions specific to the study of art and art history, with the aim of helping you produce better papers for your art and art history classes.

How to Generate Ideas

While looking at the artwork or group of artworks you've chosen or that was assigned to you, you will usually come

up with some ideas worth writing about. But what if you've looked at the artwork(s) a few times and you still haven't found anything that you feel is worth exploring? Or what if you've found an idea to write about, but you haven't yet discovered how you might develop that idea? In these situations you might want to try one of the following strategies for generating ideas.

CONVERSATION

After visiting an art exhibition, you will often talk about it with others—sometimes as soon as you leave the venue. Those conversations enable you to think about the artworks you have seen in new and interesting ways. Note, however, that the kinds of conversations you have with your friends—which are often freewheeling, opinionated, and more emotional than intellectual—mark just the beginning of your inquiry. Still, talking with friends can help to explore differences of opinion and encourages you to articulate and back up your point of view.

BRAINSTORMING

Another way to formulate ideas is to brainstorm. Brainstorming is useful because it's a quick and efficient way of laying out what you know about a subject. By brainstorming, you might also see what you don't know about a topic, which might move you to read and think further. Suppose you decided to brainstorm for a paper on Native American Mimbres pottery

(fig. 8, p. 126) found in the Southwestern United States. During your brainstorming, you note that many indigenous communities dispute the appropriateness of treating such pottery as art, as some Mimbres ceramics were buried alongside people and were not created for museum collections or public display. As a result, while these objects are often treated as art by scholars, curators, and college instructors, they involve challenging questions about ethical approaches to the study of indigenous cultural practices. You might make a list like this:

Mimbres pottery:
- Is part of the Native American Mogollon culture, which was located in current-day New Mexico
- Was produced from *c.* 600 to 1150 CE, with production at its height between 900 and 1150 CE
- Is made from ceramics, and most examples have black painted imagery
- Was likely produced mainly by women artists
- Uses geometric, organic, and figurative decorations, with depictions of animals and figures that may be deities
- Suggests that people in the Mogollon culture probably had contact with other Native American cultures, including the Ancestral Pueblo people
- Has been subject to Western collecting and display practices that are counter to many Native American cultural practices
- Has been subject to racist assumptions and stereotypes about Native American people and cultural practices

Fig. 8: Mimbres bowl, 9th–12th century CE, from current-day New Mexico. Ceramic and pigment, height 5 in. (12.7 cm), diameter 11 in. (27.9 cm). Metropolitan Museum of Art, New York.

- Has, like many examples of Native American cultural practice, been subject to cultural appropriation

As this list illustrates, *brainstorming* is an informal strategy in which you jot down, as quickly as you can, ideas concerning your topic. The ideas don't have to be connected—though

looking for connections often yields a paper topic. For instance, you might write about how Ancestral Pueblo cultural practices relate to the imagery found on Mimbres pottery; or about recent efforts by some Western museums to incorporate Native American art into existing displays of European-descent U.S.-based art, examining whether such developments are important examples of greater inclusion that demonstrate diversity or problematic instances of cultural appropriation that betray Native American cultural traditions.

Remember that you can also stop at any point in the writing process to brainstorm, especially when you feel that you're stuck or that you have to fill in some gaps in your argument. In short, when you brainstorm you freely explore your topic without the pressure of structure, grammar, or style. In the process, ideas for an essay (or a paragraph, or even a footnote) evolve unhindered.

FREEWRITING

Freewriting is similar to brainstorming in that it is a quick and informal way to develop an idea. But whereas brainstorming most often involves making a list of ideas, freewriting requires that you try to elaborate on these ideas by writing about them. In this way, freewriting can get you "unstuck" when coming up with ideas is difficult. Below is an example of freewriting about the *Chi-Rho* page from the *Book of Kells*

(see fig. 10, p. 132). Note that, since it is meant for the writer's eyes only, this freewriting is very informal—with spelling, grammar, and punctuation errors intact.

ok, so i have to write this paper about the chi-rho page, and i don't know how to get started. i just looked at a whole bunch of pictures of it, and wow, it is visually stunning. even though it is from a book, there isn't much actual text on the page, but the forms that are there—the letters chi, rho, and iota, which make up the name "Christ" in Greek—are truly amazing. not easy to read, but so much decoration! the sweeping curve of the chi especially caught my eye because it is so elongated and elegant, and it is filled with shapes and patterns (circles set in squares, curlicues, and other stuff). there are lots of outlines and multicolor borders around the edges of different forms, and all around the actual letters there is more of the same kind of intricate decoration filling the in-between spaces and covering the page. there are also a couple of recognizable forms in the imagery—a pair of figures standing next to each other and a solo figure that looks like it has wings (maybe an angel?). also the head of what looks like a boy or young man with short hair at the end of the spiral of the rho. but even with these small figures, the thing that this page most reminds me of is some of the jewelry that we've seen from this same time. some of the designs on the chi-rho page have the same kinds of patterned linework that is filled in with areas

of color, and the page also uses the same kind of repetition of abstract forms (both organic and geometric) that i remember from medieval jewelry. those objects must have been really valuable. i'm guessing the same is true for the chi-rho page, because it must have taken forever to paint all those patterns and details—this page, and pages like it, must have been really important in society at that time.

DISCOVERY DRAFT

Discovery drafts are like freewriting, but with an agenda. When writing a discovery draft, you will focus on exploring a particular aspect or aspects of your topic. You will give language to the questions and observations that arise. In this process, you will almost always stumble across some new *discovery*. And with this discovery, a paper is often launched.

It might be helpful to think of a discovery draft as a letter to a friend. Suppose that you've just seen (whether in person or via reproductions) the fourteenth-century tile **mosaic** *mihrab* (prayer niche) from the city of Isfahan in Iran that is installed at the Metropolitan Museum of Art in New York City (fig. 9, p. 130). You might first summarize, for your friend's benefit, the *mihrab*'s history and its materials and construction, as well as its size, shape, color scheme, and other formal properties. You might then turn your focus to the importance of **calligraphy** and related practices in Islamic art, along with more detailed information about the three inscriptions found on the

Fig. 9: Tile mosaic mihrab (prayer niche), AH 755/1354–55 CE, from Isfahan, Iran. Ceramic, 135 x 113¾ in. (343.1 x 288.7 cm). Metropolitan Museum of Art, New York.

mihrab. Or you might describe the technical skills and challenges involved in mosaic work and note the extensive use of geometric and vegetal patterns in the tile mosaic that covers the *mihrab.* Or you might point out a particular element of the *mihrab* that you found compelling. Finally, you might address and then work out any questions you have about the topic—for instance, about Islamic art in general, or about mosaic practices, or about the *mihrab* itself. In writing the discovery draft, you will often have an "a-ha!" moment, in which you see or understand something you hadn't considered before. This "a-ha!" moment is the point of the discovery draft.

FIVE WS AND AN H

Journalism has provided us with perhaps the simplest and most familiar way of coming up with a topic: Ask questions, specifically *who, what, when, where, why,* and *how.* Initially, answering these questions may not seem very difficult—at least until one gets to the *why* and *how.* Then it can get tricky.

Let's use this method to try to generate ideas, once again, for a paper on the *Chi-Rho* page from the *Book of Kells* (fig. 10, p. 132). Maybe when you were looking at images of the *Chi-Rho* page you became interested in its use of forms that resemble the fine metalsmithing and ornamental techniques associated with jewelry, so you have a topic you want to explore. Now begin your interrogation:

Fig. 10: *Chi-Rho* page, from the *Book of Kells*, *c.* 800. 13 x 10 in. (33 x 25.5 cm). Library at Trinity College, Dublin.

Who made the *Chi-Rho* page? What connections might these artists have had to fine metalsmithing and jewelry? (Identify the artists if possible, or note their particular artistic training and knowledge.)

What specific aspects of jewelry are evident in the *Chi-Rho* page? What particular types of jewelry does the page resemble? (List the jewel-like properties of the artwork.)

How do these artists replicate the properties of jewelry in the *Chi-Rho* page? (Consider the painting materials, skills, or other properties used to create the artwork.)

Where on the page are the jewel-like properties most evident? (Identify particular areas/elements of the artwork.)

Where was the *Chi-Rho* page produced, and what was happening with fine metalsmithing and jewelry production in or near this location? (Summarize the possible geographic connections between the *Chi-Rho* page and jewelry-making.)

When was the *Chi-Rho* page produced, and what was happening with fine metalsmithing and jewelry production at this time? (Summarize the possible historical connections between the *Chi-Rho* page and jewelry-making.)

Why might the artists have borrowed visual properties of fine metalsmithing and jewelry for manuscript lettering and illumination?

The final question, in particular, is difficult to answer. But it's precisely when you have difficulty answering a question that a real paper is beginning. When the answer comes too easily, you're on familiar ground, so you're probably not saying anything interesting. Cultivate a taste for confusion. Then cultivate a strategy for clearing up that confusion. It's only when you ask a question that initially confuses you that real thinking and real writing can begin.

TAGMEMICS

Tagmemics is a system that allows you to look at a single object from three different perspectives. One of these perspectives (or even all three) can help you determine a subject for writing. By extending an analogy regarding the different ways physicists think about light, tagmemics involves seeing your topic:

- As a particle (as a thing in itself)
- As a wave (as a thing changing over time)
- As part of a field (as a thing in its context).

Suppose you want to write a paper on Édouard Manet's (1832–1883) *Olympia* (fig. 11). If you use tagmemics as a system of invention, you will begin by looking at *Olympia* as a thing in itself. In other words, what elements of this painting are worth noting? Here, think specifically about both the artwork's formal properties and its content.

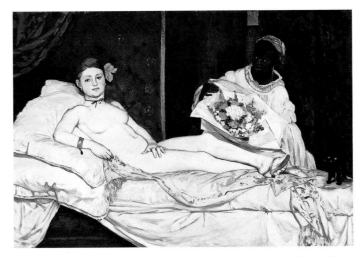

Fig. 11: Édouard Manet, *Olympia*, 1863. Oil on canvas, 51¼ x 74⅞ in. (130 x 190 cm). Musée d'Orsay, Paris.

Next you might consider how understandings of the painting have changed over time. How was the artwork received in its day? How does this reception compare to current assessments of Manet's work? Consider subsequent artworks that make reference to *Olympia*, such as Paul Cézanne's (1839–1906) *A Modern Olympia* (1873–74) or Suzanne Valadon's (1865–1938) *The Blue Room* (1923). How do these artists change Manet's experiments with painting techniques? How do they modify Manet's portrayal of the reclining female nude?

Finally, consider Manet's *Olympia* as a thing in context. Relate it to its culture, to its moment in time. What was happening in the world in the 1860s? France was in the midst of the

Second Empire era, during which there were rapid changes in industry and technology (such as the expansion of the railway system), massive modifications to urban infrastructure (such as the "**Haussmannization**" of Paris, which modernized the city with redesigned housing, public parks, and wide-open boulevards), and expansions of urban entertainment (such as the construction of the Opéra). Might these events be reflected in the painting in some way? How? And why?

ARISTOTLE'S TOPOI

As one of the fathers of rhetoric, Aristotle worked to formalize a system for conceiving, organizing, and expressing ideas. We're concerned here with what Aristotle called the "topoi"—a system of specific strategies for invention (which we've outlined below). Think of the topoi as a series of questions that you might ask of the artwork you are going to write about. The topoi are especially helpful when you're asked to explore a topic that seems very broad.

Let's consider how using the topoi can help you write a paper on the importance of Edmonia Lewis's (*c.* 1844–1907) work as an example of nineteenth-century Neoclassical sculpture in the United States.

Use Definition

Using definition can help you come up with ideas in two ways. First, you might look at *genus*, which Aristotle explains

as defining a general idea *within specific limits.* For example, you could define the characteristics of Neoclassicism in nineteenth-century US sculpture with the intent of showing how Lewis's work epitomizes the style.

The second way to use definition is to think in terms of *division.* In other words, think of your subject *in terms of its parts.* For example, you could consider the specific elements of Lewis's work that make it an important example of nineteenth-century US sculpture.

Use Comparison

Making comparisons can help you generate ideas in two ways. The first is to look for *similarities* and/or *differences.* For example, you might determine how Lewis's work stands apart from other examples of Neoclassical sculpture in the United States during the nineteenth century.

The second method is to compare *degree.* In other words, you might consider how something is better or worse than something else. For example, is Lewis's sculpture a more important example of nineteenth-century US Neoclassicism than the work of Hiram Powers (1805–1873)? Is it less important to the style than Harriet Hosmer's (1830–1908) sculpture?

Explore Relationships

Aristotle determined four ways of exploring relationships as a way of coming up with ideas for writing. The first is to consider either the *cause* of your subject or its *effects.* For example, you

might research the historical forces that enabled Lewis—an African American and Native American woman—to pursue a career as a professional artist beginning in the 1860s. Or, you might study the effects that Lewis's work had on subsequent sculpture produced in the United States during the later nineteenth and twentieth centuries.

Second, you might consider a subject's *antecedent* and *consequences*. In other words, you might ask of your subject: If this, then what? For example, if Lewis hadn't produced such artworks as *Forever Free* (fig. 12), would subsequent artists have depicted themes associated with slavery, the Civil War, and the Reconstruction era in the United States in different ways?

Third, you might examine *contraries*, making an argument by proving its opposite. Along these lines, you might argue that Lewis is the most significant of the nineteenth-century Neoclassical sculptors from the United States by showing how other sculptors working in the same style at the same time miss the mark.

Finally, you might look for *contradictions, incompatible statements,* or *controversy.* For example, some critics and historians feel that Lewis is the most significant nineteenth-century US Neoclassical sculptor; others feel that her work is atypical for the style. You can explore the debate and stake a claim of your own.

Examine Circumstances

Examining circumstances can help you develop your ideas in two ways. The first is to *consider the possible and the impossible.*

Fig. 12: Edmonia Lewis, *Forever Free*, 1867. Marble, height 41¹/₄ in. (104.8 cm). Howard University Art Gallery, Washington, D.C.

For example, you might argue that it's impossible to find a nineteenth-century sculptor from the US whose work more directly engages issues of race and gender than Lewis.

The second strategy is to *consider the past or to look to the future.* For example, in what ways did Lewis's work influence the work of subsequent sculptors? What developments does her work display that might relate to more recent, current, or future developments in sculpture practice, or in art history more generally?

Rely on Testimony

The opinions of others can provide important sources for your paper. You'll therefore want to look to authorities, testimonials, statistics, maxims, laws, and precedents. For instance, how did nineteenth-century audiences and critics respond to Lewis's work? What did they think of her work in comparison to that of other Neoclassical sculptors at the time? What have more recent art critics and historians argued about Lewis's work and her contributions to art history?

Developing Your Ideas

You've done some preliminary brainstorming. Perhaps you've even completed a discovery draft. The problem sitting before you now is that you have too many ideas and you don't know what to do with them, or the ideas you've come up with don't seem to be adequately academic. What do you try next?

NUTSHELLING

Nutshelling is the simple process of trying to explain the main point of your observations in a few sentences—in a nutshell. When you put your thoughts in a nutshell, you come to see just how those thoughts fit together. You see how each thought is relevant to the others, and what the overall point is. In short, nutshelling helps you transform your observations or information into something meaningful, focused, and coherent.

Imagine, for example, that you're asked in an assignment to consider whether, from your point of view, Roy Lichtenstein (1923–1997) or Andy Warhol (1928–1987) is the more art historically significant Pop artist. First, although Lichtenstein produced some quintessential examples of Pop art (which you love), you think that Warhol is the more important artist of the two. Why? Well, though both artists used source materials drawn from industrially manufactured pop culture, only Warhol used industrial printing techniques (silkscreening, beginning in 1962) to produce the majority of his work. In contrast, while Lichtenstein did trace some elements of his borrowed imagery, he still tended to use typical fine art painting tools and techniques to create his work.

In your opinion, using industrial image-making processes is a major aspect of Pop art that sets it apart from other developments in twentieth-century art. However, you know others won't agree with you, because some art historians and critics

think that what makes Pop art important is its use of mass-culture imagery in conjunction with established, hand-based painting techniques that both require specialized artistic skills and retain more elitist notions of "fine art." Indeed, for these art historians and critics, without these hand-based painting techniques, Pop art would merit far less serious consideration as "Art."

In a nutshell, what is your take on the matter? After considering all of your feelings on the subject, you decide that, although Lichtenstein clearly made important art historical contributions to Pop art, Warhol's work demonstrates that Pop art introduces not only new imagery but also new image-making techniques into twentieth-century art. Stated more fully:

Both Roy Lichtenstein and Andy Warhol are widely known as Pop artists who used imagery drawn from popular culture in their work. Of the two artists, however, only Warhol also introduced major changes in image-making techniques into twentieth-century art. Specifically, Warhol combined popular, widespread imagery with silk-screening and related industrial printing practices in his work, transforming painting from an elitist fine art into a cultural practice with mass appeal. As a result, while both Lichtenstein and Warhol made important contributions to Pop art, Warhol is the more art historically significant artist.

In the process of nutshelling, you've done more than come up with a promising idea for a paper. You've also come up with a promising plan for your introduction. Nutshelling has proven to be a successful prewriting strategy in this case.

BROADENING YOUR TOPIC

What happens when you've put your thoughts in a nutshell and they seem too "small"? You may have come up with a topic that's too narrow to support a sustained conversation.

Say, for example, that you've been asked to examine the work of Frida Kahlo (1907–1954) and to consider her use of clothing in a number of paintings. You've noticed that Kahlo depicts herself in certain types of clothing in various paintings, including *Frida and Diego Rivera* (1931); *Self-Portrait on the Border Line between Mexico and the United States* (1932); *Self-Portrait with Bed* (1937); *Itzcuintli Dog with Me* (c. 1938); *The Two Fridas* (1939); and *Tree of Hope* (1946). In *Memory* (1937), Kahlo depicts herself wearing one outfit (a mid-length white dress with a multicolor jacket or cardigan) while she is flanked by two others. And in *Self-Portrait with Cropped Hair* (1940), Kahlo wears an oversized man's suit. Finally, in several artworks, including *Self-Portrait with Medallion* (1948), Kahlo appears in a close-up, bust-length portrait in which her face emerges from an extensive headdress that fully covers her neck and shoulders.

With all of these different artworks in mind, you've made notes about the types of clothing that Kahlo uses throughout

her work, and you think that you can write an essay that examines the artist's use of clothing as a central element of her paintings. But it isn't enough simply to describe the different examples of clothing that Kahlo portrays. Instead, you have to articulate *how* Kahlo uses clothing in her paintings and then make a declaration about what this use of clothing *means*.

After writing your discovery draft, you come up with the idea that Kahlo's paintings use clothing to draw attention to indigenous Mexican cultural heritage. Though this observation is promising, it still isn't "big" enough. Why not? Because it remains an observation, not an argument. It lists *how*, in certain paintings, Kahlo depicts certain types of clothing that are associated with indigenous, pre-Hispanic cultural traditions in Mexico, but it does not address *why* these types of clothing, and these cultural traditions, are important. How do you broaden your topic so that you feel you have something more substantial to say?

First, try to make connections. Does Kahlo use clothing to communicate any other messages or meanings in her work? Is clothing linked only to cultural themes in her paintings, or perhaps also to political concerns? Or are there other elements of her paintings that Kahlo also uses to draw attention to indigenous Mexican culture? In what other ways does the artist explore these topics in her work?

Second, turn your idea inside out. Consider the other side of the matter. For example, in some paintings, Kahlo may use clothing to focus on pre-Hispanic Mexican cultural heritage,

but in others her outfits may call attention to other cultural traditions. Alternatively, in some artworks, clothing may focus on something other than cultural heritage, such as events in Kahlo's life. These possibilities merit further exploration.

Third, consider the context. There are several different contexts to consider: the context of Kahlo's work and career; the context of early twentieth-century modernism; the context of early twentieth-century Mexican art; and the context of post-revolutionary Mexico in the early twentieth century (among other possibilities). Note also that these different contexts overlap with one another. Within the context of Kahlo's work, you might check to see if Kahlo uses clothing to emphasize indigenous cultural heritage at a particular moment in her career. Does she explore this theme exclusively in the early years of her career? The later years? Or throughout her work? You might also look for other types of imagery and content that Kahlo uses to investigate these themes. Does she always depict herself when she explores these themes, or are there paintings that address these issues but do so with other figures or imagery as well?

Similarly, in the context of early twentieth-century art—including modernism, Mexican art, and/or some combination of these areas of study—you might look for other artists who use clothing to depict similar cultural traditions, or other artworks that use clothing to communicate meanings more generally. Consider some of the other historical forces at work. What is the significance of an artist exploring

pre-Hispanic cultures in Mexico during the 1930s and 1940s? What larger social issues or historical events might Kahlo be examining? Finally, clothing has a long history of communicating various messages about heritage and identity. What can you learn about the history of clothing in relation to these themes that is relevant to the matter at hand?

All of these questions might help you broaden your topic so that your discussion is substantial and interesting.

FOCUSING YOUR TOPIC

What if your topic seems too big to handle? What do you do then? Let's consider the hypothetical writing assignment about Kahlo's work that we were just discussing.

Perhaps after doing the various prewriting exercises, you've concluded that you definitely want to write a paper about the ways that Kahlo uses clothing to explore indigenous Mexican cultural heritage. Although this observation is potentially fruitful, you should resist the temptation to be satisfied with it. After all, a paper showing that, in one painting after another, Kahlo depicts clothing that highlights indigenous Mexican culture and history will probably bore the reader. It will seem like a string of obvious and general observations. How do you focus your topic?

First, test your claim. A statement as broad as this one is probably not always true. Do Kahlo's artworks use clothing to explore indigenous Mexican heritage exclusively, or are

there other elements of Mexican culture and history that Kahlo also calls attention to? You might discover that Kahlo also occasionally uses clothing to acknowledge European culture and history, or to signal her identity as an artist. Or, you might find that Kahlo uses not only clothing but also other imagery to highlight indigenous Mexican heritage. These more focused observations can lead to a more interesting and manageable topic.

Then consider your examples. Remember that broad is also *vague*. Focusing on specific examples can make a topic clearer. For instance, you might want to write only about Kahlo's solo self-portraits, or you might want to include portraits in which Kahlo paints herself accompanied by others. Does Kahlo use one type of portrait more frequently or consistently than the other in exploring indigenous Mexican heritage? Or is there some other recurring formal property that sets this theme apart from others in the artist's work?

Finally, consider the context. Just as a consideration of context can help you broaden an idea, it can also help you focus it. "Frida Kahlo uses clothing in her paintings to explore indigenous Mexican heritage" can become "Historically, portraits have frequently used clothing to communicate key features of subjects' cultural identities. Frida Kahlo uses clothing in her X self-portraits to highlight indigenous Mexican heritage in Y and Z ways." Then, show (1) what particular types of self-portraits Kahlo uses to explore her indigenous Mexican heritage; and (2) the specific messages

and meanings Kahlo highlights about this heritage in these particular self-portraits.

Essentially, you are looking for details that support your specific claim while simultaneously weeding out other aspects of Kahlo's work because they're not important to your argument. If you fail to go through that process, you may end up including extraneous information in your essay, and your instructor will likely tell you that the paper seems disorganized. If you do a good job of narrowing your focus, that won't be a problem.

Thinking beyond the Frame

So far, we've been advising you to consider primarily the formal aspects and content of art in generating your ideas. As we pointed out earlier, however, you can write about art in several ways. Sometimes you will want to "think beyond the frame" and consider questions about how art was made, its historical context, and so on. Keeping in mind what you learned in Chapter 3, ask yourself the following questions:

Who made the artwork? Use the artist as the focal point for your writing assignment. Look at the range of artworks the artist created to develop a better understanding of the formal properties and/or specific types of content that interested the artist. Or examine the artist's biography to consider the ways in which life events may have informed his or her work.

What is the historical context of an artwork or an artistic style? See what you can learn about the time period in which an artwork was made or during which an artistic style developed. Théodore Géricault's (1791–1824) *Raft of the Medusa* (1819), for example, depicts the shipwreck of the French frigate *Medusa*, a tragic event that had recently occurred (in 1816) and that the nineteenth-century French Restoration government tried to cover up. The painting's representation of this event also contributed to its unconventional exhibition history. Knowing something about the time period in which an artwork was made can help you understand many of the decisions that the artist made in creating the work.

What can you learn from an artwork's style? In conjunction with viewing an artwork you have decided to write about, think about the key characteristics of the style with which it is associated. When you view the artwork, consider how these characteristics are reinforced or changed. Géricault's *Raft of the Medusa* is a painting that displays the artist's academic training, especially in relation to life drawing skills that recall Neoclassicism and other earlier styles. However, Géricault's painting also introduces new approaches to composition and content that characterized the emergence of Romanticism in France. Knowing how these newer approaches played out in other examples of Romanticism (in France as well as other locations) will help you understand and appreciate Géricault's accomplishment.

What do critics and scholars say? Reading what others have said about an artwork before you view it may help you focus your observations. For instance, if many architectural historians consider certain structures to demonstrate especially notable achievements in construction and engineering—as is the case with such buildings as the Great Pyramid at Giza in Egypt (c. 2575–2450 BCE), the Great Stupa at Sanchi in India (c. 150–50 BCE), the Pantheon in Rome (110–128 CE), Hagia Sophia in current-day Istanbul (532–537 CE), and the Inca site at Machu Picchu in current-day Peru (1450–1530; fig. 13), to name just a few examples—then you'll want to pay close attention to the technical advances evident in these buildings.

Who supported the production of a particular artwork or an individual artist? Consider what you can discover about the role a patron or an institution might have played in supporting the production of an artwork or the career of an artist. Did a particular patron provide an artist with financial or other types of support in exchange for early or exclusive access to his or her work? Was an artwork produced for a specific patron, or exhibited in a particular venue? What can you learn about an artwork's or artist's exhibition record over time, and are there any notable patterns in such exhibition histories?

Does an artwork or exhibition reflect an interesting cultural phenomenon? Sometimes a professor will ask you to view certain artworks because she wants you to examine

Fig. 13: Machu Picchu, 1450–1530, current-day Peru.

a cultural phenomenon—for example, debates about the return (also called the **repatriation**) of certain artifacts to their nations of origin. Accordingly, you might review the history of the so-called "Elgin Marbles," the Classical Greek sculptures (*c.* 447–438 BCE) removed from the Parthenon at the beginning of the nineteenth century that are currently part of the collection at the British Museum in London. You might also read about various international agencies and laws that dictate rules about the conditions under which art

and artifacts can be removed from their countries of origin. You might examine accounts of the Acropolis Museum, built by the Greek government and opened to the public in 2009 as part of their campaign to have the Parthenon Marbles returned to Greece. Note that this type of paper might focus especially on historical and other contextual changes that have contributed to shifting attitudes about cultural heritage and related issues.

If asking these questions leads you to a promising topic but you find that you don't know enough to write about the topic without reading other sources, then you will need to conduct research in order to write your paper. The next chapter provides some guidance on the research process.

5

Researching Art

Doing research in an art or art history class is in many ways similar to doing research for other classes: You'll visit the library or the library's databases, find books and journals, get a clear sense of the scholarly conversation, and then offer a perspective of your own. One important difference, though, is that when you write about art, the art itself is typically the primary source, with art history, theory, and criticism (books, journal articles, and so on) serving as secondary sources.

Understanding Primary and Secondary Sources

Primary sources are defined as any text, image, object, film, or other medium that is the object of scholarly investigation. A *secondary source*, on the other hand, is a work that analyzes, comments on, or otherwise sheds light on the primary text,

historical event, object, or phenomenon in question. A source can be primary or secondary, depending on the purpose of your research. For instance, you might write an art history paper in which the primary text is something other than art itself (e.g. an artist's diary, an art museum's history of its exhibition practices, or an art gallery's archives of its sales records). Or you might write a paper in which a secondary source consists of photographs and/or films (e.g. photographic and/or film documentation of an artist at work in his or her studio).

As we continue this discussion about research, we'll be talking in most cases about secondary sources that comment on artworks—for example, art history, art criticism, theoretical articles, etc.

Using Sources

Research is most efficient when you have a strategy for collecting and employing sources. No one wants to wander from source to source trying to remember what, precisely, that source argued, or why it mattered in the first place. We therefore offer the following research tips, which we think will help you become a more effective and efficient researcher.

It may seem at first that these steps take time. "Why should I stop to summarize a source when I can simply go back to the original?" you might wonder. The strategies outlined here, however, will save you time in the long run. The work you do to digest and classify your sources as you do your research

will make the writing process much more focused, much more efficient, and much less painful in the end.

SUMMARIZE YOUR SOURCES

Before attempting to use any source in your paper, make sure you understand it. The best way to do this is to summarize the source. In summarizing, you accomplish a few things. First, summarizing a source requires you to put the argument in your own language. Some of your secondary sources might use language that puzzles you. When you summarize, you are, in a sense, translating an argument into language that you understand and can work with. Summarizing also helps you see whether there's any aspect of the argument that you aren't getting. If you find yourself stumbling as you attempt to summarize, go back to the original source for clarity.

Summarizing also allows you to restate an argument in terms that are relevant to your paper. Most art history, theory, and criticism that you will encounter is very complex and offers several ideas for consideration. Some of these ideas will be relevant to your topic, while others will not. When you summarize, you can restate the part of the argument that seems most relevant to the paper you want to write.

Summarizing can also help you organize your source material. If you've used ten sources in a research project, you've probably taken a lot of notes and have gathered several quotations for your paper. This work can amount to pages

and pages of text. Summaries can help you organize these notes by telling you almost at a glance which idea comes from which source. You can also include in your summaries a few of the best quotations from each source.

Finally, summarizing is helpful to the entire research process. It's not something that you should do once at the beginning of the research process and then forget about. Every time your understanding of the topic shifts or evolves, take the time to write a brief summary. You'll find that putting your thoughts into writing helps you solidify one stage of understanding before progressing to the next.

CATEGORIZE YOUR SOURCES

Once you've summarized your sources, try to place them into various categories. Remember, writing an academic essay is like taking part in a large, ongoing conversation. Although everyone has a particular point of view, it's safe to say that no one is entering the conversation as a lone wolf. Everyone is speaking from a certain critical perspective. These perspectives might be classified into different groups.

Categorizing your sources might be as simple as looking for similarities among them. Which sources seem to share a point of view? Which seem to arrive at similar conclusions? You will also discover differences among your sources. Try to define these differences and see if they seem to fall into different categories. For example, side A seems to believe X, while

side B seems to believe Y. Or, side A attempts to understand the artwork(s) under consideration from a feminist perspective, while side B is interested in interpreting the art from a socioeconomic perspective.

Once you've categorized your sources, try to understand what these differences and similarities mean to your argument. Are these categories relevant to the issues you intend to discuss? Where does your own argument fit in? Does the reader need to know about these categories for your argument to make sense? Try to articulate these matters clearly. Write a summary of what you think at this point.

INTERROGATE YOUR SOURCES

In most of the papers that you'll write in college, you'll have to do more than review what other people have said about a topic. You will be asked to present your own point of view. To do this, you'll need to interrogate your sources.

Interrogating your sources does not mean that you have to be contentious. You don't have to search like a bloodhound for the weak spot in an argument. You're not required to "take on" your source. Instead, you'll want to ask questions of your sources. Initiate a conversation. Challenge, interrogate, rebut, and confirm. Some good questions to ask are the following:

Is the writer supporting the claim(s) with evidence? Is this evidence sufficient? Why or why not?

Is there something that the writer is overlooking or omitting? If so, is the omission a matter of carelessness, or does it seem purposeful? Why?

Does the writer's argument seem reasonable? If not, can you locate places where the reasoning seems to break down? Can you locate and identify any logical fallacies?

Is the writer's language appropriate? Does the writer sometimes rely on a pretty phrase or a passionate claim to cover up a lack of evidence?

What can you determine about the writer's perspective? Does the writer seem to have any important biases? Does the writer seem to belong to a particular critical school of thought? Does the writer's perspective help or hinder the argument he or she is trying to make? Why?

Where do you stand in relation to the writer? Do you approve or disapprove of the writer's argument? Are you sitting with your brow furrowed, feeling skeptical, or are you nodding thoughtfully as you read? Keep notes regarding your personal responses to the source, and try to translate those responses into comments or questions.

ANNOTATE YOUR SOURCES

Most scholars find it useful whenever possible to mark their texts as they read them—not simply by highlighting important passages, but by making note of their questions and reactions in the margins. Marking your text enables you to enter into conversations with the author. No longer are you reading passively. Instead, you are reading actively, filling the margins with comments and questions that could blossom into a paper topic down the road. Annotating your text also ensures that your questions and inspirations won't get lost. Entire books have evolved from notes made in the margins. The ideas for these books might have been lost had the writer not taken the time to write them down.

MAKE YOUR SOURCES WORK FOR YOU

Students often make a grave mistake when they write their first academic papers: Overwhelmed by what their sources have to say, they permit their papers to crumble under the weight of scholarly opinion. They end up not writing an informed argument of their own but rehashing what has already been said on a topic. Such a paper might be informative. It might also be competently written. But it does not fulfill the requirements of a good academic paper. Remember, a good academic paper must be analytical, it

must be critical, and it must present a well-crafted, persuasive, informed argument.

Consider the phrase *informed argument*. The word with the power in this phrase is the noun *argument*. The word *informed* is merely a descriptor. It serves the noun, qualifying it, coloring it. The information that you gather should serve your argument in much the same way. Make your sources work for *you*.

You can take some steps to ensure that your sources do indeed work for you without overwhelming your argument. First, don't go to the library or go online before you've thought about your topic on your own. Certainly your research will have an impact on what you think. Sometimes you might even find that you reverse your opinion. But if you go to the library before you've given your topic some thought, you risk jumping on the bandwagon of the first persuasive argument you encounter.

Second, limit your sources to those that are relevant to your topic. It's easy to be swept up in the broader scholarly conversation about your subject and to go off on tangents that don't, in the end, serve your argument.

Finally, keep track of your evolving understanding of the topic by periodically stopping to summarize. As we said earlier, summarizing your sources makes them more manageable. If you manage your sources as you go along, you will reduce the risk that they'll overwhelm you later.

Keeping Track of Your Sources

During the research process it's very important to keep track of your sources. Nothing is more frustrating than having a great quotation and not knowing where it came from. Develop a good, consistent system for keeping notes.

Every academic discipline requires that you submit with your paper a bibliography or list of works cited. A bibliography should include every work you looked at in your research, even if you didn't quote that source directly. A list of works cited, on the other hand, is just that: a list of works that you quoted, paraphrased, or alluded to in the text of your paper. Both bibliographies and lists of works cited require you to provide information that will make it easier for your reader to find these sources. Consult the *MLA Handbook* or the *Chicago Manual of Style* for information about how to construct a proper bibliography and/or list of works cited.

Citing Sources

When you write an academic paper, you must cite all the sources that you've used, even if you don't quote them directly. If you fail to cite these sources, you will be charged with plagiarism. Plagiarism (passing off as your own the words and ideas of others, whether an entire article or just one phrase) is an academic offense for which there are serious consequences.

We can offer several good reasons not to plagiarize. First, it's very easy to get caught. Your instructors—who have spent years teaching and so have read countless student essays— are keenly aware of the difference between professional and student writing. They notice when sophisticated, highly polished academic writing appears out of the blue, with seemingly no development or context. In addition, although technology makes plagiarism easy, it also empowers teachers, who can utilize sophisticated search programs to scan literally millions of documents for suspect phrases and sentences.

Second, plagiarism cheats both the reader and the writers whom you are quoting. At a fundamental level, citing a source is an academic courtesy. Because scholarship is an ongoing conversation, you should always presume that other students or scholars could want to use your work to develop their own. If you've taken an idea from another scholar but haven't cited it (or have cited it improperly), your reader will have no easy way of finding the source of the ideas that have found their way into your work.

Perhaps the most serious problem raised when you plagiarize or fail to cite your sources is that you're cheating yourself. When you rely on the ideas of others to meet a course requirement, you're denying yourself the opportunity to have the best experience that college can offer: the opportunity to think for yourself. Writing papers can be difficult, and when deadlines loom, it can be tempting to look for a shortcut and to lift ideas from scholars who clearly know more about your

topic than you do. But it's *your* opinion that your instructor wants to hear. Take each writing assignment as an opportunity to explore and express your ideas. You're paying a lot for this education; you might as well get your money's worth.

6

Developing Your Thesis

Writing a Thesis Sentence

No sentence in your paper will vex you as much as the thesis sentence, and with good reason: The thesis sentence is very often the one sentence in the paper that asserts, controls, and structures the entire argument. Without a strong, persuasive, thoughtful thesis—explicit or implied—a paper might seem unfocused, weak, and not worth the reader's time.

What makes a good thesis sentence? A good thesis sentence generally has the following characteristics:

A good thesis sentence makes a claim. This doesn't mean that you should reduce an idea to an *either/or* proposition and then take a stand. Rather, you need to develop an interesting perspective that you can support and defend. This

perspective must be more than an observation. "During the late nineteenth and early twentieth centuries, modernism introduced new approaches to both form and content in the visual arts" is merely an observation (verifiable by a wide range of art historical sources). "During the late nineteenth and early twentieth centuries, modernism in the visual arts introduced far more experiments in form than in content" is an argument. Why? Because it puts forward a perspective. It also makes a claim that engages competing claims. Put another way, a good thesis sentence inspires (rather than silences) other points of view. Someone else might argue that, during the late nineteenth and early twentieth centuries, modernism introduced more experiments in content than in form. Another person might claim that, although modernism introduced many experiments with both form and content, its innovative approaches to form made more substantial and lasting changes in the visual arts. If your thesis is positing something that no one can (or would bother to) argue with, then it's not a very good thesis.

A good thesis sentence determines the scope of the argument. The thesis sentence determines what you're required to say in a paper. It also determines what you cannot say. Every paragraph in your paper exists to support or develop your thesis. Accordingly, if one paragraph you've written seems irrelevant to your thesis, you have three choices: Get rid of that paragraph, rewrite the thesis sentence

to accommodate the paragraph, or work to make the paragraph more clearly relevant. Understand that you don't have a fourth option: You can't include the paragraph without making clear its connection to your thesis. The thesis is like a contract between you and your reader. If you introduce ideas that the reader isn't prepared for or doesn't find relevant, you've violated that contract.

A good thesis sentence provides a structure for the argument. The thesis sentence signals to the reader not only what your argument is, but also how it will be presented. In other words, your thesis sentence should either directly or indirectly suggest the structure of your argument to the reader. Say, for example, that you're going to argue the following idea: "During the late nineteenth and early twentieth centuries, modernism introduced three key formal innovations that would forever change artistic practice: A, B, and C." In this case the reader understands that you're going to cover three important points, and that these points will appear in a certain order. If you suggest a particular ordering principle and then abandon it, the reader could feel confused and irritated.

Alternatives to the Thesis Sentence

Sometimes the purpose of a piece of writing is not to make a claim, but to raise questions. Other times a writer wants to leave a matter unresolved, inspiring readers to create their

own positions. In these cases the thesis sentence might take other forms: the thesis question or the implied thesis.

As we've said, not every piece of writing sets out to make a claim. If your purpose as a writer is to explore, for instance, the influences that have informed the work of graphic designer Chaz Maviyane-Davies (b. 1952) (a topic for which you're not prepared to make a claim), your thesis question might read: "How does Chaz Maviyane-Davies incorporate previous design styles and practices, as well as social and political issues, in his graphic design work?"

Note that this question, while provocative, does not offer a sense of the argument's structure. It permits the writer to pursue all ideas, without committing to any. Although this freedom might seem appealing, in fact you will find that the lack of a declarative thesis statement requires more work: You need to tighten your internal structure and your transitions from paragraph to paragraph so that the essay is clear and the reader can easily follow your line of inquiry.

To illustrate, let's suppose that you want to use the thesis question, "What social and political issues have been central to the development of Chaz Maviyane-Davies's design work?" You might start by discussing some of the recurring topics or themes that Maviyane-Davies has communicated in his graphic design projects, such as those related to human rights, social justice, and environmental concerns (among others). You might describe the ways these themes overlap in his work, or the chronological development of these different

topics over the course of Maviyane-Davies's career thus far. Or you might examine Maviyane-Davies's biography to gain a better understanding of some of the major events—in both politics and his personal life—that have shaped his commitments to graphic design as a practice that can contribute to social and political change.

You can see that there's a lot of material to cover here—perhaps too much. If you don't know where the paper will lead or what your conclusions will be, you might find it difficult to avoid digressing into irrelevant tangents. Therefore, if you're going to use a thesis question, make sure that it's a clearly articulated question and that you can structure a well-ordered investigation in response. If the paper starts to feel unwieldy, you might decide instead to use the question as the beginning of a discovery draft. Your findings in the discovery draft can then lead to a declarative thesis for the essay.

THE IMPLIED THESIS

One of the most fascinating things about a thesis sentence is that it is the most important sentence in a paper—even when it's not there.

Some of the best writers never explicitly declare a thesis. In some essays you'll find it difficult to point to a single sentence that declares the argument. Still, the essays are coherent and make a point. In these cases the writers have used an implied thesis.

Writers sometimes use an implied thesis when they want readers to come to their own conclusions about the matter at hand. Just because writers don't declare the thesis, however, doesn't mean that they are working without one. Good writers will clearly state a thesis—either in their own minds or in their notes for the paper. They may elect not to put the thesis in the paper, but each paragraph and each sentence that they write is controlled by the thesis all the same.

If you decide to write a paper with an implied thesis, be sure that you have a strong grasp of your argument and its structure. Also be sure that you supply adequate transitions so that the reader can follow your argument with ease.

When you begin writing, you should have a solid, well-articulated thesis. The thesis will tell your readers the purpose of your essay, and as you write it will help guide you. It's also important to keep in mind that the thesis you have when you begin is not set in stone; you can still modify it. Often you'll find that, as you write, your thoughts about the issue will evolve, and you'll refine your conclusions. Sometimes it will be necessary to change your thesis to reflect those changes in your thinking. Therefore, when you begin writing, what you really have is a *working thesis*. It can change and adapt and develop as you write the paper. A working thesis doesn't necessarily become a final thesis until the paper is finished.

Turning Your Ideas into a Thesis

Now that we've looked at what a thesis must accomplish, let's take a moment to look at creating one based on the pre-drafting work you've already done. Let's say you've done some brainstorming, a little freewriting, and maybe written a discovery draft, and you've come up with some interesting thoughts. After that, you spent a little time nutshelling, trying to focus your ideas. Now you just need to convert one of those focused ideas into a working thesis.

Composing a working thesis is challenging. After all, the thesis is arguably your paper's most important sentence. It cannot be crafted formulaically but must reflect the complexities of the argument that you plan to write. But even while no formula exists for writing a successful thesis, we can offer you some advice to get started.

First you'll need to determine what you want to write about. Since you've already created some ideas through brainstorming, freewriting, and other exercises, you should have some options.

From the list of observations you developed during these idea-generating exercises, you'll want to find an observation that interests you. You might choose a single observation from your list and focus on it, or you might look for an idea that ties together two or three of these observations, and focus on that. Whatever you decide, don't try to squeeze everything you've observed into a single essay. To do so would require a

book—and you simply don't have time to write a book before the paper is due. Determining which idea or set of ideas you want to work with will enable you to stay focused and do justice to your ideas in the limited time that you have.

Sometimes writers are torn between two or three very good observations. If the ideas can't be synthesized into a single idea or claim, the best strategy is to pick whichever observation looks most interesting. In other words, choose the observation you can be most engaged with. Doing so will help you stay focused: You will now know not only what you'll want to discuss, but also what you can leave alone.

You'll also notice something interesting at this point: Even though you don't yet have a thesis, the observation you've chosen to write about will help dictate which type of paper you're writing. For instance, if your observation has to do with the ways that the visual properties of fine metalsmithing and jewelry in medieval illumination practices indicated the social and cultural value of medieval manuscripts (as in the example of the *Chi-Rho* page discussed in Chapter 4, pp. 127–29 and pp. 131–33), then you'll be writing a social art history paper. Realizing this helps you understand not only what you're going to do, but also what you're *not* going to do: a biographical or a Marxist analysis, for example.

So let's imagine that you have a focus for your paper: You're going to write a specific type of paper (social art history) about the ways that the resemblance between the *Chi-Rho* page and fine metalsmithing and jewelry signals the social

and cultural significance of manuscript illumination during the Middle Ages. As we discussed earlier in this guide, your goal in writing a social art history paper is to consider art for its impact on society, noting the ways that art interacts with other elements of society, such as religion, economics, or politics. At this point you need to compose a question, using this goal to guide you. After some doodling you come up with this question: How does the *Chi-Rho* page use the visual properties of fine metalsmithing and jewelry to showcase the social and cultural importance of manuscript illumination at the time? Give yourself the opportunity to explore that question. Brainstorm or freewrite a response. Then try to shape your response so that you can answer the question in a couple of sentences, then a single sentence. When you can answer that question in one sentence, you'll have your working thesis.

Alternatively, if you intend to write a paper that uses technical approaches to art history, you will ask yourself a different question, based on the goals of that type of paper. For instance, you might investigate whether there were any technical advancements in painting techniques or manuscript production associated with the *Chi-Rho* page. Or, you might explore the complexities involved in conserving the **parchment** materials used in the *Book of Kells*, and in medieval manuscripts more generally. The same is true for a paper that analyzes the Christian iconography of the *Chi-Rho* page. The strategy is clear: Instead of trying to create a thesis out of thin air, pick an element of an artwork, artistic style, or art

historical development that interests you, then ask yourself a relevant question based on the goals of the *type* of paper you're going to write. When you are able to answer your own question, you'll have a working thesis.

The Thesis Sentence Checklist

In the end, you may have spent a good deal of time writing your working thesis and still not know if it's a good one. As we've indicated earlier, a good thesis typically evolves as the writer writes. As you write, you'll want to interrogate your thesis in order to determine how well it's holding up. Some questions to ask yourself follow:

Does the thesis sentence attempt to explore or answer a challenging intellectual question? Consider the question you are posing. If your question doesn't challenge you, it likely won't challenge your reader either. Nor will it lead to a thesis that you and your reader will care about. If you find yourself bored as you write, or if you are haunted by the sense that you aren't talking about anything important, stop writing. Return to your list of observations. See if you can find some connection between the observations that might raise the intellectual stakes.

Will the point I'm making generate discussion and argument, or will it leave people asking "So what?"? If your

thesis doesn't generate discussion, perhaps the point you made is too obvious. Return to your list of observations. Ask of each one, "Why is this important—to the study of this artwork, artist, and/or artistic style, and to the study of art and art history in general?" The answer to this question should help you refine your thesis.

Is the thesis too vague? Too general? If a thesis is too broad, it's unlikely to hold the reader's interest. It's also unlikely to give you a clear sense of direction for your paper. Try to be more specific in your focus. Take your more general idea and apply it to specific observations about the artwork. Perhaps in that application you'll find the focus for your paper.

Does the thesis deal directly with the topic at hand, or is it a declaration of my personal feelings? Be careful about personal opinions: As we've noted, making a claim is different from stating an opinion. An academic paper does the former but rejects the latter.

Does the thesis indicate the direction of my argument? Does it suggest a structure for the paper? If a thesis is well constructed, it will suggest to you and to your reader where the paper is going. Look at your thesis, then look at your outline. Does your thesis suggest or reflect that outline? Can you rewrite the thesis so that it suggests your outline or other structure for your paper?

Does the introductory paragraph define terms important to my thesis? Don't make your thesis do all the work. Rely on your introduction to help your thesis, especially when it comes to necessary but cumbersome tasks, such as defining terms.

Does the introduction place my thesis within the larger, ongoing scholarly discussion about the topic? Consider again the dinner party metaphor (see Chapter 1, p. 15). What do the scholars at the table have to say about the topic? What do you have to say in response to their ideas? Is the relationship between your perspective and theirs clear to the reader? If not, how might it be made clear?

7

Considering Structure and Organization

Once you've figured out what you want to say, you're left with the problem of how to say it. How should you begin the paper? Should you address the opinions of other thinkers? And what should you do with that stubborn contradiction you've uncovered in your own thinking? Writing papers in college requires you to come up with sophisticated, complex, and even creative ways of structuring your ideas. Accordingly, we can't offer simple formulas that will work for every paper. We can, however, give you some things to think about that will help as you consider how to structure your paper.

Let Your Thesis Direct You

Begin by listening to your thesis. If it's well written, it will tell you which way to go with your paper. Suppose, for example,

that in responding to the paintings of the nineteenth-century French painter Jean-Léon Gérôme (1824–1904), you have written a thesis that says this:

> Gérôme's work demonstrates the ways that nineteenth-century French Orientalism is defined by picturesque scenes that display not only a heightened sense of Western superiority but also blatant distortions of non-Western cultures.

This thesis provides the writer with several clues about how best to structure the paper. It also prepares readers for what they will encounter therein. First, the thesis promises readers that the paper will argue that nineteenth-century French Orientalism employs picturesque imagery emphasizing attitudes of Western superiority. The paper will therefore begin by articulating Gérôme's use of picturesque properties in his work and by analyzing the ways this imagery contributed to nineteenth-century French assumptions of Western superiority. The paper will also note that imagery in support of notions of Western superiority is not the only feature of Orientalism in Gérôme's paintings. Most importantly, the paper will address the distorted imagery of non-Western cultures that appears in many of Gérôme's artworks and throughout nineteenth-century French Orientalism.

We say that this distorted imagery of non-Western cultures is more important than notions of Western superiority not

necessarily because this was the case in nineteenth-century French Orientalism, but because the writer seems to say so in the thesis. Reread the thesis sentence. Note that the emphasis falls on the last clause: "blatant distortions of non-Western cultures." This emphasis tells us that we will be given not simply a description of how nineteenth-century French Orientalism supported notions of Western superiority but, rather, a description of how these notions were justifed and reinforced by glaring inaccuracies in nineteenth-century French perceptions of non-Western cultures. We understand all of this because the writer took the time to make sure that the thesis was written emphatically. (For more discussion of how to write emphatic sentences, see Chapter 8, "Attending to Style.")

Sketching Your Argument

Although your thesis will identify your paper's general direction, it will not necessarily provide you with a plan for how to organize all of your points, large and small. Here it might be helpful to diagram or "sketch" your argument.

In sketching your argument, the goal is to fill the page with your ideas. Begin by writing your thesis. Put it where your instincts tell you to: at the top of the page, in the center, or at the bottom. Around the thesis, cluster the points you want to make. Under each of these points, note the observations you've made and the evidence you'll use. Don't get nervous when your sketch starts to look messy. Use arrows.

Draw circles. Take up colored pens. Any of these methods can help you find connections between your ideas that might otherwise go unnoticed. Working from your sketch, try to see the line of reasoning that is evolving.

Sketching is an important step in the writing process because it allows you to explore visually the connections between your ideas. If you skip sketching and outline your paper too early in the process, you risk missing these connections. You might line up your points—A, B, C—without fully understanding how they are connected. Sketching your argument helps you see, for example, that points A and C overlap and need to be thought through more carefully.

Outlining Your Argument

When you've finished the sketch, you're ready to make an outline. The task of the outline is to identify the paper's best structure. By "best structure" we mean the structure that best supports the argument you intend to make.

When you're outlining a paper, you'll have many options for organization. Understand, however, that each choice you make eliminates dozens of other options. Your goal is to come up with an outline in which all of your choices support your thesis.

Treat the outline as if it were a puzzle that you are putting together. In a puzzle, each piece has only one appropriate place. The same should be true of your paper. If it's easy to

shift your ideas around—if several of your paragraphs could be switched around without consequence—then you haven't yet found the best structure for your paper. Each paragraph should present a single, well-supported idea that is the logical successor to the ideas that preceded it, all of them building inexorably toward your paper's overall point: the thesis. Keep working until your outline fits your ideas like a glove.

When you think you have an outline that works, challenge it. The first outline rarely holds up to a good interrogation. When you start asking questions of your outline, you will begin to see where the plan holds and where it falls apart. Here are some questions you might ask:

Does my thesis control the direction of the outline?

Are all of my main points relevant to the thesis?

Can any of these points be moved around without changing something important about the thesis?

Does the outline seem logical?

Does the argument progress, or does it stall?

If the argument seems to take a turn midstream, does the thesis anticipate that turn?

Do I have sufficient support for each of my points?

Have I made room in the outline for other points of view about the topic?

Does this outline reflect a thorough, thoughtful argument? Will that argument persuade my readers that my claims are sound?

Constructing Paragraphs

Imagine that you've written the thesis. You've interrogated the outline. You know which modes of arrangement you intend to use. You've settled on a plan that you think will work. Now you have to go about the serious business of constructing paragraphs.

You may have been told in high school that paragraphs are the workhorses of a paper. Indeed they are. If a single paragraph is incoherent or weak, the entire argument might fail. It's important that you consider carefully the "job" of each paragraph. Know what you want that paragraph to do, and make sure that it does it.

WHAT IS A PARAGRAPH?

Readers expect, when they encounter a paragraph, that it's going to declare an argument point and then offer support

for that point. If you violate this expectation—if your paragraphs wander aimlessly among three or four points, or if they declare points without offering any evidence to support them—readers will become confused or irritated by your argument. They won't want to read any further.

WHAT SHOULD A PARAGRAPH DO?

When you write good paragraphs, you are partnering with your reader to make sense of the many complicated points of your argument. You'll therefore want to make sure that your paragraphs are:

Supportive. A good paragraph supports and develops the thesis. It also declares its relationship to the thesis, making its purpose in the overall argument clear.

Focused. A good paragraph focuses on a single, well-articulated argument point. It doesn't muddy the argument by focusing on too many ideas. Nor does it proceed to make its argument without declaring what, in fact, it is trying to argue.

Strong. A good paragraph isn't bloated with irrelevancies or redundancies. Nor is it underdeveloped, lacking evidence and/or analysis. Rather, a good paragraph is intellectually "muscular." It derives its intellectual muscle from its evidence and its reasoning.

Considerate. A good paragraph is considerate of its relationships to other paragraphs. It both builds from the paragraph that came before and delivers a more developed argument to the paragraph that follows. It makes sense within the text as a whole.

WRITING THE TOPIC SENTENCE OR GUIDING CLAIM

Just as every paper requires a thesis sentence to assert and control its argument, so does every paragraph require a topic sentence to assert and control its main idea. Without a topic sentence, your paragraphs could seem jumbled or aimless. Your reader could become confused. Because the topic sentence plays such an important role in your paragraph, it must be crafted with care. When you've written a topic sentence, ask yourself the following questions:

Does the topic sentence declare a single point of the argument? Because the reader expects that a paragraph will explore only one argument point, it's important that your topic sentence not be too ambitious. If it points to two or three ideas, perhaps you need to consider developing more paragraphs.

Does the topic sentence further the argument? Give your topic sentences the same "So what?" test that you gave your thesis sentence. If your topic sentence isn't interesting and

clear in its purpose, your paragraph probably won't further the argument. Your paper could stall.

Is the topic sentence relevant to the thesis? It might seem so to you, but the relevance may not be so clear to your reader. If you find that your topic sentence is taking you into brand-new territory, stop writing and consider your options. If the new territory isn't relevant to the existing thesis, either you'll have to rewrite your thesis to accommodate this new direction, or you'll have to consider excluding this paragraph from your final paper.

Is there a clear relationship between this topic sentence and the paragraph that came before? Make sure that you haven't left out any steps in the process of building your argument. If you take a sudden turn in your reasoning, signify that turn to the reader by using the proper transitional phrase— "on the other hand," "however," or the like.

Does the topic sentence control the paragraph? If your paragraph seems to unravel, take a second look. Perhaps the topic sentence isn't adequately controlling the paragraph and needs to be rewritten. Or, maybe the paragraph is moving on to a new idea that needs to be developed in a paragraph of its own.

Where have I placed my topic sentence? Readers often look for topic sentences at or near the beginning of a paragraph.

Consider this: If you are skimming something quickly, which sentence do you look to in each paragraph? Likely it's the first sentence. This doesn't mean all of your topic sentences need to be situated at the beginning of your paragraphs. Nevertheless, if you're going to place your topic sentence elsewhere, you'll need to craft your paragraph with care. You might justify putting the topic sentence in the middle of the paragraph, for example, if you have information that needs to precede it. You might also justify putting the topic sentence at the end of the paragraph, if you want the reader to consider your line of reasoning before you declare your point. Let the argument and what it needs dictate where you place your topic sentence. Wherever you place it, be strategic. Make sure that your decision facilitates your argument.

Developing Your Paragraphs

EVIDENCE

Students often ask how long a paragraph should be. To this we respond, "As long as it takes."

It's possible to make a point quickly. Sometimes it's desirable to keep it short. Notice the preceding paragraph, for example. We might have hemmed and hawed, talked about short paragraphs and long paragraphs. We might have said that the average paragraph is one-half to two-thirds of a page in length. We might have spent time explaining why

the too-short paragraph is too short, and the too-long paragraph too long. Instead, we cut to the chase. After rambling through this paragraph (which is getting longer and longer all the time), we'll give you the same advice: A good paragraph is as long as it needs to be in order to illustrate, explore, and/or prove its main idea.

Length, however, isn't all that matters in paragraph development. It's not even a paragraph's most important feature. What's important is that a paragraph develops its idea fully, and in a manner that readers can follow with ease.

Let's consider these two issues carefully. First, how do we know when an idea is fully developed? If your topic sentence is well written, it should tell you what the paragraph needs to do. If the topic sentence declares, for example, that there are two competing messages communicated in a particular artwork, then the reader will expect the two messages to be explained and demonstrated. It might take two paragraphs to do this; it might take one. The decision will depend on how important this matter is to the discussion. If the point is important, you'll take your time, and (more likely than not) you'll use at least two paragraphs. In this case a topic sentence might be understood as controlling not only a paragraph but also an entire section of text.

After writing a paragraph, ask yourself these questions:

Do I have enough evidence to support this
 paragraph's idea?

Do I have too much evidence?

Does this evidence clearly support the assertion that I'm making in this paragraph, or am I stretching it?

If I'm stretching it, what can I do to persuade the reader that this stretch is worth making?

Am I repeating myself in this paragraph?

Have I defined all of the paragraph's important terms?

Can I say, in a nutshell, what the purpose of this paragraph is?

Has the paragraph fulfilled that purpose?

ARRANGEMENT

Equally important to the idea of a paragraph's development is the matter of the paragraph's arrangement. Paragraphs are arranged differently for different purposes. For example, if you're writing a paper about the historical development of a particular artistic style and wish to summarize a sequence of events, you'll likely want to arrange the information chronologically. If you're writing a paper in which you want to describe the formal properties of an artwork, you might choose to arrange the information from most to least—or least to most—visually noteworthy. For instance, if an artwork's use of color is highly experimental, you might lead with a description and analysis of these experiments, or, conversely, you might build up to these points within a paragraph. If you're writing a paper about the elements of

an artwork that make it stand out from other artworks in a similar artistic style—or that shares a similar type of content with artworks in the same style—you might want to arrange your ideas by working from the specific to the general. The point is to think about what purpose you want the paragraph to serve, and then to come up with an organizational strategy that will help your paragraph achieve that purpose.

COHESION

At some point in the composing process, you'll have a thesis, topic sentences, and sufficient evidence to support your argument. You will have constructed your argument in a way that makes sense to you. But when you read the essay back to yourself, you feel a profound sense of disappointment. Though you've followed your outline, the essay just doesn't seem to hold together. It could be that you have a problem with cohesion.

A lack of cohesion is easy to diagnose but not so easy to cure. An incoherent essay doesn't seem to flow. Its arguments are hard to understand. The reader has to double back again and again in order to follow the gist of the argument. Something has gone wrong. What? To improve cohesion in your paper, look for the following issues.

Make sure the grammatical subjects of your sentences reflect the real subject of your paragraph. Underline the subjects of all the sentences in the paragraph. Do these subjects match the paragraph's subject in most cases? Or have you put the paragraph's subject into another, less important part of the sentence? Remember that the reader understands an idea's importance according to where you place it. If your main idea is hidden as an object of a preposition in a subordinate clause, do you really think your reader is going to follow what you're trying to say? For instance, consider the following paragraph about the ways that Frida Kahlo uses clothing in her work to explore indigenous Mexican cultural heritage. The grammatical subject of each sentence is indicated in boldface.

Throughout her work, **Frida Kahlo** highlights the importance of pre-Hispanic cultural heritage in Mexico. **One** of the most common ways that Kahlo explores this theme is through imagery of clothing associated with indigenous Mexican culture, such as the Tehuana dress. For instance, in *My Dress Hangs There* (1933), **a Tehuana dress** appears in the center of the image, surrounded by industrial and urban imagery. Also, **paintings** such as *Self-Portrait with Bed* (1937) and *Itzcuintli Dog with Me* (*c*. 1938) portray Kahlo wearing a Tehuana dress. In these artworks, **the political significance** of cultural heritage in post-revolutionary Mexico is indicated by indigenous clothing, which

is further connected to Kahlo's political commitments in the aftermath of the Mexican Revolution.

Look at the five subjects: "Frida Kahlo," "one," "a Tehuana dress," "paintings," and "the political significance." Of these, only "a Tehuana dress" is clearly related to the topic of the paragraph. Now consider this revised paragraph:

Throughout Frida Kahlo's work, **clothing** symbolizes the importance of pre-Hispanic cultural heritage in Mexico following the Mexican Revolution. In particular, **the Tehuana dress**, with its indigenous huipil or tunic-like top and full skirt, recurs in Kahlo's paintings. For instance, in *My Dress Hangs There* (1933), **a Tehuana dress** hangs in the center of the image. Similarly, in paintings such as *Self-Portrait with Bed* (1937) and *Itzcuintli Dog with Me* (*c*. 1938), **Kahlo** depicts herself prominently positioned in the middle of the canvas, wearing a Tehuana dress. In these artworks, **indigenous clothing** signals the political significance of pre-Hispanic cultural heritage in post-revolutionary Mexico, and above all Kahlo's combined political and cultural commitments to Mexican freedom from Western imperialism.

Look at the subjects here: "clothing," "the Tehuana dress," "a Tehuana dress," "Kahlo," and "indigenous clothing." The paragraph's string of related subjects keeps the reader focused

on the topic and creates a paragraph that flows more naturally and seems much more cohesive than the first one.

Make sure the grammatical subjects are consistent. Again, look at the grammatical subjects of all your sentences. How many different subjects do you find? If you have too many different sentence subjects, your paragraph will be hard to follow.

Make sure your sentences look backward as well as forward. For a paragraph to cohere, each sentence should begin by linking itself firmly to the sentence that preceded it. If the link between sentences does not seem firm, use an introductory clause or phrase to connect one idea to the other.

Follow the principle of moving from old to new. If you put the old information at the beginning of the sentence and the new information at the end, you accomplish two things. First, you ensure that your readers are on solid ground, moving from the familiar to the unknown. Second, because we tend to give emphasis to what comes at the end of a sentence, readers rightly perceive that the new information is more important than the old.

Use repetition to create a sense of unity. Repeating key words and phrases at appropriate moments will give your readers a sense of coherence in your work. But don't overdo it; you'll risk sounding redundant.

Use transition markers wisely. Sometimes you'll need to announce to your readers a turn in your argument, or you'll want to emphasize one point, or you'll want to make clear a particular relationship in time. In all these cases you'll want to use transition markers. Some examples of such markers, and when to use them, are:

- **To give an example:** *for example, for instance*
- **To present a list:** *first, second, third, next, then*
- **To show that you have more to say:** *in addition, furthermore, moreover*
- **To indicate similarity:** *also, likewise, similarly*
- **To show an exception:** *but, however, nevertheless, on the other hand*
- **To show cause and effect:** *accordingly, consequently, therefore, because*
- **To emphasize:** *indeed, in fact, of course*
- **To conclude:** *finally, in conclusion, in the end.*

Introductions and Conclusions

Introductions and conclusions are among the most challenging of all paragraphs. Why? Because they must do more than state a topic sentence and offer support. Introductions and conclusions must synthesize and provide context for your entire argument, and they must also make the proper impression on your readers.

The introduction is your chance to get readers interested in your subject. Accordingly, the tone of the paragraph has to be just right. You want to inform, but not to the point of being dull; you want to intrigue, but not to the point of being vague; you want to take a strong stance, but not to the point of alienating readers. Pay attention to the nuances of your tone. Seek out a second reader if you're not sure that you've managed to get the tone the way you want it.

Equally important to the tone of the introduction is that it needs to "place" your argument into a larger context. Some strategies follow:

Announce your topic broadly, then declare your particular take. For example, if you're interested in writing about controversial uses of religious imagery in late twentieth-century art, you might (1) begin by providing a quick overview of the controversy as others have defined it; (2) identify one or two key artworks in which the use of religious imagery has proved to be controversial (e.g. Andres Serrano's *Piss Christ*, from 1987, or Chris Ofili's *The Holy Virgin Mary*, from 1996); and (3) declare your thesis (which states your own position on the matter).

Provide any background material important to your argument. If you're interested in exploring how the relationships between the social classes in Edo-period Japan contributed to the development of **ukiyo-e** imagery in eighteenth- and

nineteenth-century Japanese woodblock prints (fig. 14, p. 196), then in your introduction you'll want to provide the reader, in broad strokes, with a description of these socioeconomic relationships. Don't include irrelevant details in your description; instead, emphasize those aspects of the relationships (such as the increased economic strength of the artisan and merchant classes) that might have most influenced the development of *ukiyo-e* imagery.

Define key terms as you intend to make use of them in your argument. If, for example, you're writing a paper on *vanitas* themes in Baroque still-life paintings, it is absolutely essential that you define the term for your reader. For example, how do you understand the term *vanitas*? Begin with a definition of terms, and from there work toward the declaration of your argument.

Use an anecdote or a quotation. Sometimes you'll find a terrific story or quotation that seems to reflect the main point of your paper. Don't be afraid to begin with it. Be sure, however, that you tie that story or quotation clearly and immediately to your main argument. Also be sure that this anecdote or quotation is really the best way to begin—too often students use an anecdote or quotation to catch the reader's attention, but the anecdote or quotation isn't clearly relevant to the point of the paper, or it sets a tone that is not academic.

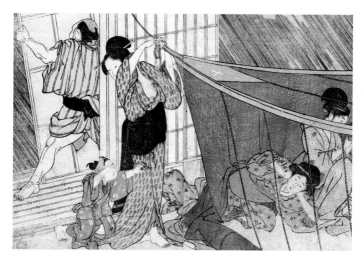

Fig. 14: Kitagawa Utamaro, *The Coming Thunderstorm* (from the illustrated book *Flowers of the Four Seasons*), 1801. Polychrome woodblock print, 6⅞ x 9 ⅛ in. (17.5 x 25.1 cm). Metropolitan Museum of Art, New York.

Acknowledge your opponents and/or those with whom you align. When you're writing a paper about a controversial matter, you might wish to begin by summarizing the point of view of your adversaries. Conversely, you might summarize the scholarship with which you align. Then state your own position in relation to these. Either way, you place yourself clearly in the ongoing conversation.

Remember, the introduction is the first impression that your argument will make on the reader. Take special care

with your sentences so that they'll be interesting. Also take the time to consider who your readers are and what background they will bring with them to their reading. If your readers are very knowledgeable about the subject, you will not need to provide a lot of background information. If your readers are less knowledgeable, you will need to be more careful about defining terms.

While introductions allow you the chance to make a first impression, conclusions provide an opportunity to leave the reader with something to think about. For this reason, conclusions can be difficult to write. How do you manage to make the reader feel persuaded by what you've said? Even if the points of your paper are strong, the overall effect of your argument might fall to pieces if the paper as a whole is badly concluded.

Many students end their papers by simply summarizing what has come before. A summary of what the reader has just read is important to the conclusion, particularly if your argument has been complicated or has covered a lot of ground. But a good conclusion will do more. Just as the introduction sought to place the paper in the larger, ongoing conversation about the topic, so should the conclusion insist on returning readers to that ongoing conversation, but with the feeling that they've learned something more. You don't want readers to finish your paper and say, "So what?" Admittedly, writing a conclusion isn't easy. Many of the strategies we've listed for improving introductions can help you improve your conclusions as well. In the conclusion you might do the following:

- Return to the ongoing conversation, emphasizing the importance of your own contribution to it.
- Consider again the background information with which you began, and illustrate how your argument has shed new light on that information.
- Return to the key terms and point out how your essay has added new dimensions to their meanings.
- Use an anecdote or a quotation that summarizes or reflects your main idea.
- Acknowledge your opponents—if only to emphasize that you've countered their positions successfully.

Remember, language is especially important to a conclusion. Your goal in the final sentences is to leave your ideas resounding in the reader's mind. Give the reader something to think about. Make your language ring.

8

Attending to Style

Most of us know good style when we see it—and *hear* it in the mind's ear. We also know when a sentence seems cumbersome to read. Though we can spot beastly sentences easily, it is not as easy to say why a sentence—especially one that is grammatically correct—isn't working. We look at the sentence; we see that the commas are in the right places; and we find no error to speak of. So why is the sentence so awful? What's gone wrong?

When thinking about what makes a good sentence, be sure to put yourself in your readers' place. What are readers hoping to find in your sentences? Information, yes. Eloquence, surely. But, most important, readers are looking for *clarity*. Your readers do not want to wrestle with sentences. They want to read with ease. To see one idea build on another. To experience, without struggling, the emphasis of your language and the importance of your idea. Above all, they want to feel that you, the writer, are doing the bulk of the work.

In short, they want to read sentences that are persuasive, straightforward, and clear.[22]

The Basic Principles of the Sentence

FOCUS ON ACTORS AND ACTIONS

To understand what makes a good sentence, it's important to understand one principle: A sentence, at its most basic level, is about actors and actions. As such, the subject of a sentence should point clearly to the actor, and the verb of the sentence should describe the important action vividly.

This principle might seem so obvious to you that you don't think it warrants further discussion. But think again. Look at the following sentence, and then try to determine, in a nutshell, what's wrong with it:

There was a belief on the part of some nineteenth-century French art critics that the use of loose brushwork in Impressionist paintings was an indication that these artworks lacked artistic skill and were unfinished.

22 Joseph Williams and his work were a major influence on how teaching about style is represented here. For a thorough examination of the fundamental principles of style, see Williams's *Style: Lessons in Clarity and Grace*, 12th ed. (New York: Pearson 2017).

This sentence has no grammatical errors. But certainly it lumbers along, without any force. Who are the actors? What are the actions?

Now consider the following sentence:

> Some nineteenth-century French art critics believed that Impressionist paintings, with their characteristic loose brushwork, were unskilled and unfinished.

What changes does this sentence make? We can point to the more obvious changes: omitting the empty *there was* phrase; replacing the abstract noun *belief* with the verb *believe;* replacing the wordy phrase *was an indication of* with the stronger, more precise *with their characteristic;* replacing the phrase *lacked artistic skill* with the adjective *unskilled;* omitting all of the prepositions that the abstract nouns and longer phrases require. What principle governs these many changes? Precisely the one mentioned earlier: that the *actors* in a sentence should serve as the sentence's grammatical subjects, and the *actions* should be illustrated forcefully in the sentence's verbs.

Whenever you feel that your prose is hard to follow, find the actors and the actions of your sentences. Is the actor the subject of your sentence? Is the action described vividly, in a verb? If not, rewrite your sentences accordingly.

BE CONCRETE

Student writers tend to rely too heavily on abstract nouns. They use *expectation* when the verb *expect* is stronger; they write *evaluation* when *evaluate* is more vivid. So why use an abstract noun when a verb will do better? Many students believe that abstract nouns permit them to sound more "academic." When you write with a lot of abstract nouns, however, you risk confusing your reader. You also end up cornering yourself syntactically. Consider the following:

Nouns often require prepositions. Too many prepositional phrases in a sentence are hard to follow. Verbs, on the other hand, can stand on their own. If you need some proof of this claim, consider the following sentence:

> Mondrian's description of avant-garde art during the early twentieth century provides a methodological outline for his approach to painting.

Notice all of the prepositional phrases that these nouns require. Now look at the following sentence, which uses verbs:

> Mondrian describes early twentieth-century avant-garde art and outlines his approach to painting.

This sentence has fewer nouns and prepositions and is therefore much easier to read—yet it still conveys all the information found in the prior sentence.

Abstract nouns often invite the *there is* (or *there are*) construction. Consider the following sentence:

There are many means by which this painting perpetuates stereotypes, especially in relation to race and gender.

We might rewrite this sentence as follows:

This painting perpetuates many racist and sexist stereotypes.

The result, again, is a sentence that is more direct and easier to read.

Abstract nouns are, well, abstract. Using too many abstract nouns will leave your prose seeming ungrounded. Words like *falsification*, *beauteousness*, and *insubstantiality* sound pompous and vague. People simply don't talk this way. Instead, use concrete nouns, as well as strong verbs, to convey your ideas. *Lying*, *beauty*, and *flimsiness* reflect the way people really speak; these words point directly to their meanings without drawing undue attention to themselves.

Abstract nouns can obscure your logic. Note how hard it is to follow the line of reasoning in the following sentence (the nouns that might be rewritten as verbs or as adjectives are in boldface):

> One point of connection between Dada and Surrealism is their **shared** attitude about the role of the artist, and especially their **deemphasis** of creative intention and artistic control.

Now consider this sentence:

> Dada and Surrealism **share** a key attitude about the role of the artist: Both movements **deemphasize** creative intention and thus undermine artistic control.

The Exception: When to Use Abstract Nouns

In some instances an abstract noun will be essential to the sentence. Sometimes abstract nouns refer to a previous sentence (*these arguments, this decision*, etc.). Other times they allow you to be more concise (e.g. *their argument* versus *what they argued*). In other cases, the abstract noun is a concept important to your argument: freedom, love, revolution, and so on. Still, if you examine your prose, you'll probably find that you overuse abstract nouns. Omitting from your writing those abstract nouns that aren't really necessary makes for leaner, "fitter" prose.

BE CONCISE

Readers are easily exasperated when writers don't write concisely. These writers use phrases when a single word will do. They offer pairs of adjectives and verbs where one is enough. Or they overwrite, saying the same thing two or three times with the hope that the reader will be impressed by a point worth rephrasing and then rephrasing again.

Don't make the same mistakes! It's easy to delete words and phrases from your prose once you've learned to be ruthless about it. Do you really need such words as *actually, basically, generally,* and so on? If you don't need them, why are they there? Are you using two words where one will do? Isn't the phrase *first and foremost* redundant? What's the point of *future* in *future plans*? And why do you keep saying, *"In my opinion"*? Doesn't the reader understand that this is your paper, based on your point of view?

Sometimes you won't be able to fix a wordy sentence by simply deleting a few words or phrases. You'll have to rewrite the whole sentence. Take the following sentence, for example:

Plagiarism is a serious academic offense resulting in punishments that might include suspension or dismissal, profoundly affecting your academic career.

The idea here is simple: *Plagiarism is a serious offense with serious consequences.* Why not simply say so?

BE COHESIVE

At this point in discussing style, we move from the sentence as a discrete unit to the way that sentences fit together. Cohesion (or the lack of it) is a common problem in student papers. Sometimes a professor encounters a paper in which all the ideas seem to be there, but they're hard to follow. The prose seems jumbled. The line of reasoning is confusing. Couldn't the student have made this paper more readable?

Although cohesion is a complicated and difficult matter to address, we can offer a couple of tricks that will help your sentences "flow." To manage this, follow the simple principle of old-to-new. In other words, most of the sentences you write should begin with the old—with something that looks back to the previous sentence. Your sentence should then move on to telling the reader something new. If you do this, your line of reasoning will be easier for readers to follow.

Though this advice sounds simple enough, it is not always easy to follow. Let's dissect the old-to-new practice so that we can better understand how our sentences might "flow."

Consider, first, the beginnings of sentences. The "flow" of your paper depends largely on how well you begin sentences. When you begin a sentence, you have three important matters to consider:

Is your topic also the subject of the sentence? As discussed in the previous chapter, in effective sentences, the focus or topic is also the grammatical subject. If, for instance, you're writing a sentence whose topic is the importance of loose brushwork in Claude Monet's paintings, then the grammatical subject of the sentence should reflect that idea:

> Monet's **loose, dab-like brushwork** gives life to the bustling movement of people on the street.

If, on the other hand, you bury your topic in a subordinate clause, look what happens:

> The bustling movement of people on the street is given life through the loose, dab-like brushwork Monet uses in the painting.

The emphasis and focus of the sentence are obscured.

Are the topics/subjects of your sentences consistent? For a paragraph to "flow," most of the sentence subjects should be the same. To check for consistency, pick out a paragraph and make a list of its sentence subjects, similar to our earlier example. See if any of the subjects seem out of place. For example, if you're writing a paragraph about the importance of loose brushwork in Impressionist paintings, do most of your sentence subjects reflect that paragraph topic? Or, do some of

your sentences have other, tangential topics (such as "movement" or "modernity") as the grammatical subject? Although the sense of dynamic movement associated with modernity in nineteenth-century Paris may indeed have a place in your paper on Impressionist brushwork, you will confuse readers if your paragraph's sentences have a variety of subjects that point to many competing ideas. Revise the sentences (perhaps the entire paragraph) to improve their focus.

Have you marked, when appropriate, the transitions between ideas? Cohesion depends on how well you connect a sentence to the one that came before it. You'll want to make solid transitions between your sentences, using such words as *however* or *therefore*. You'll also want to signal to readers whenever, for example, something important or disappointing comes up. In these cases you'll want to use expressions like *note that* or *unfortunately*. You might also want to indicate time or place in your argument. If so, you'll use these kinds of transitions: *then, later, earlier,* or *in the previous paragraph*. But be careful not to overuse transition phrases. Some writers think transition phrases can, all by themselves, direct a reader through an argument. Indeed, sometimes all a paragraph needs is a *however* in order for its argument suddenly to make sense. More often, though, problems with coherence stem from the fact that writers have not articulated, for themselves, the connections between their ideas. Don't rely on transition phrases alone to bring sense to muddled prose.

BE EMPHATIC

We've been talking about how sentences begin, but what about how they end? If the beginnings of sentences must look over their shoulders at what came before, the ends of sentences must forge ahead into new ground.

To write emphatically, follow these principles:

Declare important ideas at the end of a sentence. Shift less important ideas to the front.

Tighten the ends of sentences. Don't trail off, don't repeat yourself, and don't qualify what you've just said if you don't have to. Simply make your point and move on.

Use subordinate clauses to house subordinate ideas. Put all the important ideas in main clauses and the less important ideas in subordinate clauses. If you have two ideas of equal importance that you want to express in the same sentence, use parallel constructions or semicolons. These two tricks of the trade are perhaps more useful than any others in balancing equally significant ideas.

BE IN CONTROL

When sentences run on and on, readers know that a writer has lost control. Take command of your sentences. When you read over your paper, look for sentences that seem unending. Your first impulse might be to take these long sentences and divide them into two (or three or four). This simple solution often works. But sometimes this strategy isn't the most desirable one. In fact, it might lead to short, choppy sentences. Moreover, if you always cut your sentences in two, you'll never learn how a sentence can be long and complex without violating the boundaries of good prose.

What do you do when you encounter an overly long sentence? First, consider the point of your sentence. Usually it will have more than one point. Sorting out the points helps sort out the grammar. Consider carefully the points that you're trying to make, the importance of each point, and the connections between the points. Then try to determine which grammatical structure best serves your purpose.

Do these ideas belong in the same sentence? If not, create two sentences.

Are the points of equal importance? Use a coordinating conjunction (*and*, *but*, *or*) or a semicolon to join the ideas. Try to use parallel constructions when appropriate.

Are the points of unequal importance? Use subordinate clauses (*although*, *while*, *because*, and so on) or relative clauses (*that*, *which*) to join the ideas, putting the less important idea in the subordinate clause.

Does one point make for an interesting aside? Insert that point between commas, dashes, or even parentheses at the appropriate juncture in the sentence.

WRITE BEAUTIFULLY

In your career as a writer you will sometimes produce a paper that is well written but could be written better. On this happy occasion, you might wish to turn your attention to such matters as balance, parallel structure, emphasis, rhythm, and word choice. If you're interested in exploring these rhetorical tools, consult one of several excellent style manuals, such as Joe Williams's *Style: The Basics of Clarity and Grace*, William Strunk Jr. and E. B. White's *The Elements of Style*, or John Trimble's *Writing with Style*. You will find plenty of valuable advice in any one of these sources.

9

Revising Your Work

Why and How to Revise

Most of us who compose on a computer understand revision as an ongoing—even constant—process. Every time you hit the delete key, every time you cut and paste, and every time you take out a comma or exchange one word for another, you're revising.

Real revision, however, is more than making a few changes here and there. Real revision, just as the word implies, calls for *seeing again*; it requires that you open yourself up to the possibility that parts of your paper—even your entire paper— might need to be rethought and rewritten.

Achieving this state of mind is difficult. First, you might be very attached to what you've written. You might be unwilling to change a word, let alone three or four paragraphs. Second, there's the matter of time: You might sense that the paper needs major work, but it's due tomorrow, or you have

an exam in physics, or you're coming down with a cold and know that you need to sleep. Third, you might have difficulty understanding what, exactly, is wrong with your paper. Finally, you might simply be sick and tired of the paper. How can you make another pass through it when exhaustion has you in its grip? Why should you be bothered with (or let yourself be overwhelmed by) the process of revising?

Of course we might convince you that revision is worth the extra effort simply by saying that revising a paper will help you achieve a better grade. A good reader can sense when a piece of writing has been thoroughly considered and reconsidered. This consideration (and here we mean the word in both of its meanings) is not lost on your professor and will be rewarded.

More important than grades, however, is the fact that revising your papers teaches you to be a better writer. Professional writers know that to write is to rewrite. In the revision process, you improve your reading skills and your analytical skills. You learn to challenge your own ideas, thus deepening and strengthening your argument. You learn to find the weaknesses in your writing. You may even discover patterns of error or habits of organization that are undermining your papers.

Though revising takes time and energy, it also will help you become a more efficient writer down the road. If, for example, you have discovered through the revision process that you tend to bury your topic sentences in the middle of

your paragraphs, you can take this discovery with you as you draft your next paper. You may then be less likely to make that particular mistake again.

We've answered the question "Why should I revise?" The next question, of course, is "How?" There are many different kinds of revising, including the following:

Large-scale revision. Large-scale revision means looking at the entire paper for places where your thinking seems to go awry. You might need to provide evidence, define terms, or add an entirely new step to your reasoning. You might even decide to restructure or rewrite your paper completely if you discover a new idea that intrigues you, or a structure that seems to be more effective than the one you've been using.

Small-scale revision. Small-scale revision needs to happen when you know that a certain part of your paper isn't working. Maybe the introduction needs work. Maybe one part of the argument seems weak. Once you've located the problem, you'll focus on revising that one section of your paper. When you're finished you'll want to reconsider your paper as a whole to make sure that your revisions work in the context of the entire paper.

Editing. Too often students confuse editing with revision. They are not the same processes. Editing is the process of finding minor problems with a text—problems that might

easily be fixed by deleting a word or sentence, cutting and pasting a paragraph, and so on. When you edit, you're considering your reader. You might be happy with how you've written your paper, but will your reader find your paper clear, readable, and interesting? How can you rewrite the paper so that it's clearer, more concise, and, most important of all, a pleasure to read?

The very best writers revise their writing in all the ways listed here. To manage these various levels of revision, it's very important that you get an early start on your papers so that you have time to make any substantive, large-scale revisions that might be needed. Good writers also understand that revision is an ongoing process, not necessarily something that you do only after your first draft is complete. You might find, for example, that you're stuck halfway through the first draft of your paper. You decide to take a look at what you have so far. As you read, you find that you've neglected to make a point that is essential to the success of your argument. You revise what you've written, making that point clear. In the end you find that your block, your "stuckness," is gone. Why? Maybe it's gone because what was blocking you in the first place was a hole in your argument. Or maybe it's gone because you gave your brain a break. In any case, stopping to revise in the middle of the drafting process often proves wise.

Developing a Critical Eye

We have yet to address the matter of how a writer knows what he or she should revise. Developing a critical eye is perhaps the most difficult part of the revision process. But having a critical eye makes you a better writer, reader, and thinker. So it's worth considering carefully how you might learn to see your own work with the objectivity that is essential to successful self-criticism.

The first step in developing a critical eye is to get some distance from your work. If you've planned your writing process well, you'll have left yourself a day or two to take a break. If you don't have this luxury, even an hour of video games or a walk over to the printing center to pick up a hard copy of your draft might be enough to clear your head. Many writers find that their minds keep working on their papers even while their attention is turned elsewhere. When they return to their work, they bring with them a fresh perspective. They also bring a more open mind.

When you return to your paper, the first thing you'll want to do is consider whether or not the paper as a whole meets your (and your professor's) expectations. Read the paper through without stopping (don't get hung up on one troublesome paragraph). Then ask yourself the following questions:

Did I fulfill the assignment? If the professor gave you instructions for this assignment, reread them and then ask yourself

whether or not you've addressed all of the matters you're expected to address. Does your paper stray from the assignment? Have you worked to make your argument relevant, or are you coming out of left field? If the professor hasn't given you explicit instructions for this paper, you'll still want to take a moment to consider what he or she expects. What books has the professor asked you to read? What position does the professor take regarding your topic? Has the professor emphasized a certain method of scholarship (Marxism, feminism, etc.)? Has the professor said anything to you about research methods in this discipline? Does your paper seem to fit into the conversation that the professor has been carrying on in class? Have you written something that other students would find relevant and interesting?

Did I say what I intended to say? This question is perhaps the most difficult question you will ask yourself in the revision process. Many of us think that we have indeed said what we intended to say. When we read our papers, we're able to fill in any holes that might exist in our arguments with the information that we have in our minds. The problem is that our readers don't have this same information. Your challenge in revising your own writing, therefore, is to forget about what you *meant* and see only what you actually *wrote*—your meaning has to be right there in the words on the page. It's very important to think carefully about what you've said, and to think just as carefully about what you haven't said. Ask yourself the

following questions: Was I clear? Do I need to define my terms? Has every stage of the argument been articulated clearly? Have I made adequate transitions between my ideas? Is my logic solid—is it there for all to see? If the answer to any of these questions is no, you will want to revise your draft.

What are the strengths of my paper? In order to develop a critical eye, it's just as important to know when you've written well as it is to know when you've written poorly. It helps, therefore, to make a list of what you think you've done well in your draft. It's also helpful to pick out your favorite or strongest paragraph. When you find a good paragraph, sentence, or idea, think about why it's good. You'll not only be gaining an understanding of what it means to write well, but you'll also be giving yourself a pat on the back—something that's very important to do in the revision process.

What are the weaknesses of my paper? Looking for weaknesses isn't as fun as looking for strengths, but it's necessary to the revision process. Again, try to make a list of what you haven't done well in this paper. Your list should be as specific as you can make it. Instead of writing "problems with paragraphs," you might say, "problems with unity in my paragraphs," or, even more specific, "problems with the transitions between paragraphs 3 and 4, and 12 and 13." Also force yourself to determine which paragraph (or sentence) you like least in the paper. Figure out why you don't like it, and work

to make it better. Then go back through your paper and look for others like it.

Analyzing Your Work

If you've been considering the strengths and weaknesses of your paper, you've already begun to analyze your work. The process of analysis involves breaking down an idea or an argument into its parts and evaluating those parts on their merits. When you analyze your own paper, you're breaking down that paper into its parts and asking yourself whether or not these parts support the paper as you envision it.

The following checklist reiterates our earlier advice. Use it to analyze your whole paper, or use it to help you figure out what has gone wrong with a particular section of your work.

Consider your introduction:

Does the introduction place your argument in an ongoing scholarly conversation or establish the necessary context for your paper?

Does the introduction define all of your key terms?

Does the introduction draw the reader in?

Does the introduction lead the reader clearly to your thesis?

Consider your thesis:

Does the thesis say what you want it to say?

Does the thesis make a point worth considering? Does it answer the question "So what?"

Does the thesis provide the reader with some sense of the paper's structure?

Does the paper deliver what your thesis promises to deliver?

Consider your structure:

Make an outline of the paper you've just written. Does this outline reflect your intentions?

Does this outline make sense, or are there gaps in the logic—places where you've asked your readers to make leaps for which they haven't been prepared?

Is each point in the outline adequately developed?

Is each point equally developed? (That is, does your paper seem balanced overall?)

Is each point relevant? Interesting?

Underline the thesis sentence and all of the topic sentences. Then cut and paste them together to form a paragraph. Does this paragraph make sense?

Consider your paragraphs:

Does each paragraph have a topic sentence that clearly controls it?

Are the paragraphs internally coherent?

Are the paragraphs externally coherent? That is, have you made adequate transitions between paragraphs? Is each paragraph clearly related to the thesis?

Consider your argument and its logic:

Have you really presented an argument, an assertion worth making, or is your paper merely a summary or a series of observations?

Do you see any holes in your argument, or do you find it convincing?

Have you dealt fairly with the opposition, or have you neglected to mention other possible arguments concerning your topic for fear that they might undermine your own argument?

Have you supplied ample evidence for your arguments?

Consider your conclusion:

Does the conclusion sum up the main point of the paper?

Is the conclusion appropriate, or does it introduce a completely new idea?

Does the language resonate, or does it fall flat?

Have you inflated the language in order to pad a conclusion that is empty and ineffective?

Does the conclusion leave the reader with something to think about?

The final step that you'll want to take before submitting your paper is to make sure that the grammar, spelling, and punctuation throughout the paper are correct and that you've formatted it appropriately. These details may seem frustratingly minor, but errors often cause readers to grow impatient

with otherwise well-written essays. Be sure to take the time to proofread your essay carefully.

When you proofread, you need to slow down your reading, allowing your eye to focus on every word, every phrase of your paper. Reading aloud is the most effective way to make yourself see and hear what you actually *wrote*, not just what you *meant*. Remember, a computer spellchecker is not an editor; for example, the word "form" will be spelled correctly, even if you meant "from." As you read, look for common errors: spelling errors, faulty subject-verb agreement, unclear pronoun antecedents, *its/it's* confusion, *their/there* confusion, misplaced modifiers, and so on. If you have time, get the opinion of a second reader. Treat the proofreading stage as you would a word search or sudoku puzzle—that is, as a puzzle to be solved. No doubt some errors are lurking in your prose (even professional writers find errors when they proofread their own work). Make it your mission to find them and fix them.

You'll also want to format the paper correctly. Some instructors provide explicit directions about constructing a title page, choosing a font, setting margins, paginating, footnoting, and so on. Be sure to follow these instructions carefully. If the instructor does not provide directions, consult the *MLA Handbook* or *The Chicago Manual of Style* for specific advice. Instructors appreciate papers that are not only well written but also beautifully presented. In academic writing, "beauty" equals simplicity: no needless ornamentation, no

fancy fonts, and nothing to distract the reader from the sound of your writer's voice and the clarity of your thoughts.

Transferring What You Have Learned to Other Courses

One of the most profound challenges facing student writers is the process of transferring what they've learned about writing in one class to the classes that they will take in the future. Sometimes, what you learn in a class is specific to the academic discipline in which you are working. For example (as we've demonstrated throughout this book), when you analyze art, you consider line, shape, color composition, and so much more. When you analyze film, you will consider composition but will also take into account the film's sound, editing, and so on. When you analyze a political or historical or literary argument, you will consider the assumptions that the argument is built on and the logic that is used to shape those assumptions into an argument. In many social science and science classes, the success of your analysis will depend on the soundness of the methods you have used to collect your evidence. In sum, every discipline has special requirements, practices, and conventions that you will need to become familiar with before you can write well in that discipline.

Nevertheless, you'll discover a considerable amount of common ground when writing across academic disciplines.

Writing About Art has identified much of this common ground. You will carry with you to other classes the practices of close reading and careful examination. You will develop your ideas in the context of larger historical and cultural conversations. You will build upon various prewriting exercises—such as note-taking, brainstorming, nutshelling, and composing discovery drafts—as a way of exploring your ideas deeply. You will articulate interesting questions that will, in turn, lead to focused and perhaps even original claims. And you will develop sentences and paragraphs that clearly and logically present your argument in a way that is a pleasure to read.

But most of all, we hope that this book has encouraged you to see the intellectual satisfaction that you might gain by writing academically in any discipline. Writing well is never easy, but the practices promoted in this book will certainly make it a less daunting and more satisfying experience, in that you now have strategies in hand. Bring a persistent curiosity to any writing challenge. Employ the strategies that we've outlined here. In the end, we are confident that you will produce writing of which you can be proud—now, and throughout your academic career.

Glossary of Art Terms

Terms with **bold** headings below are used within the main text of this book.

Abstract: (1) art imagery that departs from recognizable images from the natural world;
(2) an artwork the form of which is simplified, distorted, or exaggerated in appearance.

Abstraction: the degree to which an image is altered from an easily recognizable subject.

Acrylic: a liquid polymer, or plastic, that is used as a binder for pigment in acrylic paint.

Actual line: a continuous, uninterrupted line.

Additive color: the colors produced from light.

Additive sculpture: a sculpting process in which the artist builds a form by adding material.

Aesthetic: related to beauty, art, and taste.

Analog: photograph, movie, or video made using a camera that chemically or magnetically records images.

Animal imagery: content that uses animals to communicate visual messages.

Animation: a genre of film made using stop-motion, hand-drawn, or digitally produced still images set into motion by showing them in sequence.

Aquatint: an intaglio printmaking process that uses melted rosin or spray paint to create an acid-resistant ground.

Arabesque: an abstract pattern derived from geometric and vegetal lines and forms.

Arbitrary color: a color that possesses no natural or realistic relation to the object depicted.

Arch: a curved or round structure that spans an opening and/or encloses a space.

Artifact: an object made by a person.

Assemblage: (1) an artwork made of three-dimensional materials, including found objects; (2) a technique of creating artworks that challenged traditional art practice in the late twentieth century by using found objects and other non-art materials.

Asymmetry: a type of design in which balance is achieved by elements that contrast with and complement one another without being the same on either side of an axis.

Atmospheric perspective: the use of shades of color and clarity to create the illusion of depth. Closer objects have warmer tones and clear outlines, while objects set further away are cooler and become hazy.

Avant-garde: an early twentieth-century emphasis on artistic innovation, which challenged accepted values, traditions, and techniques.

Axis: an imaginary line showing the center of a shape, volume, or composition.

Background: (1) the part of a work depicted as behind the main figures; (2) the part of a work depicted furthest from the viewer's space, often behind the main subject matter.

Balance: a principle of art in which elements are used to create a symmetrical or asymmetrical sense of visual weight in an artwork.

Binder: a substance that makes pigments adhere to a surface.

Biography: material outside an artwork that explores an artist's life and provides an understanding of the influences behind the artist's work.

Bird's-eye view: an artistic technique in which a scene or subject is presented from some point above it. Sometimes called aerial view or aerial perspective.

Calligraphy: the art of highly skilled, often emotive or descriptive hand lettering or handwriting.

Canon: an established collection of artworks that are regarded as pinnacle achievements in the visual arts.

Cantilever: in architecture and construction, a beam or other long structural element, anchored at one end to a support structure from which it projects outward.

Cast: a sculpture or artwork made by pouring a liquid (for example, molten metal or plaster) into a mold.

Ceramic(s): fire-hardened clay, often painted, and normally sealed with a shiny protective coating.

Chromogenic print: a photographic print made from a color negative, transparency, or digital image.

Collage: a work of art assembled by gluing materials, often paper, onto a surface. From the French *coller*, "to glue."

Color: the optical effect caused when reflected white light of the spectrum is divided into separate wavelengths.

Complementary colors: colors opposite one another on the color wheel.

Composite view: the representation of a subject from multiple viewpoints at one time.

Composition: the overall design or organization of a work.

Conceptual: relating to or concerning ideas.

Concrete: a hard, strong, and versatile construction material made of powdered lime, sand, and rubble.

Content: the meaning, message, or feeling expressed in a work of art. *See also* subject.

Context: the circumstances surrounding the creation of a work of art, including historical events, social conditions, biographical facts about the artist, and his or her intentions.

Continuous narrative: when different parts of a story are shown within the same visual space.

Contour: the outline that defines a form.

Contrast: an apparent difference between such elements as color or value (lightness/darkness) when they are presented together; sometimes subtle and sometimes drastic.

Convention: a widely accepted way of doing something; using a particular style, following a certain method, or representing something in an established or familiar way.

Corbeling: a construction technique in which pieces of wood, stone, metal, or other materials (known as corbels) are set in successive rows or layers to span and/or enclose space. Typically, each layer of corbels is offset in relation to the layer above and below it, in order to add overall strength.

Cropping: trimming the edges of an image or composing it so that part of the subject matter is cut off.

Curator: a person who organizes the collection and exhibition of objects in a museum or gallery, and negotiates interactions between artists, artworks, institutions, and the public.

Cyanotype: a photographic process using light-sensitive iron salts that oxidize and produce a brilliant blue color where light penetrates and remain white where light is blocked. A variant of this process was used historically to copy architectural drawings (e.g. blueprints).

Depth: the degree of recession in perspective.

Diagonal: a line that runs obliquely, rather than horizontally or vertically.

Directional line: implied line within a composition, leading the viewer's eye from one element to another.

Dissonance: a lack of harmony.

Dome: an evenly curved vault forming the ceiling or roof of a building.

Drypoint: an intaglio printmaking process in

which the artist raises a burr when gouging the printing plate.

Embroidery: decorative stitching generally made with colored thread applied to the surface of a fabric.

Emphasis: the principle of drawing attention to particular areas and/or content within a work.

Encaustic: a painting medium that primarily uses wax, usually beeswax, as the binding agent.

Engraving: a printmaking technique in which the artist (the engraver) gouges or scratches the image into the surface of the printing plate.

Etching: an intaglio printmaking process that uses acid to bite (or etch) the engraved design into the printmaking surface.

Expressive: capable of stirring the emotions of the viewer.

Figuration, figurative: art that portrays items perceived in the visible world, especially human or animal forms.

Firing: heating ceramic, glass, or enamel objects in a kiln to harden them, fuse the components, and/or fuse a glaze to the surface.

Focal point: (1) the center of interest or activity in a work of art, often drawing the viewer's attention to the most important element; (2) the area in a composition to which the eye returns most naturally.

Foreground: the part of a work depicted as nearest to the viewer.

Foreshortening: a perspective technique that depicts a form at a very oblique (often dramatic)

angle to the viewer in order to show depth in space.

Form: (1) an object that can be defined in three dimensions (height, width, and depth); (2) the way style, techniques, media, and elements and principles of design are used to make the artwork look (or exist) the way it does.

Formal: in art, refers to the visual elements and principles in a work.

Formal analysis: analysis of the form or visual appearance of a work of art using the language of visual elements and principles.

Formal elements: the basic vocabulary of art—line, form, shape, volume, mass, color, texture, space, time and motion, and value (lightness/darkness).

Format: the shape of the area an artist uses for making a two-dimensional artwork.

Found image or object: an image or object found by an artist and presented, with little or no alteration, as part of a work or as a finished work of art in itself.

Freestanding: any sculpture that stands apart from walls or other surfaces so that it can be viewed from a 360-degree range.

Fresco: (1) a technique in which the artist paints onto a thin plaster surface (typically a wall or ceiling, usually freshly applied and thus wet). From the Italian *fresco*, "fresh"; (2) paintings made on plaster surfaces.

Gaze: the act of intensive looking often associated with systems of power and privilege, e.g. *male gaze*, in which women are depicted

as objects of heterosexual masculine desire.

Gelatin-silver photograph: a black-and-white photograph made from light-sensitive silver halide compounds suspended in gelatin emulsion, typically coated on paper and processed in a darkroom.

Genre: (1) category of artistic subject matter, often with an established tradition and influential history of use; (2) in Western art, a type of painting that depicts scenes from everyday life.

Geometric: having regular, predictable forms and shapes derived from mathematical systems.

Gesso: plaster of paris or gypsum prepared with glue for use in painting or making bas-reliefs.

Graphic design: the use of images, typography, and technology to communicate ideas for a client and/or to a particular audience.

Grid: a network of horizontal and vertical lines; in an artwork's composition, the lines are implied.

Grisaille: painting in gray or grayish monochrome, either as a base or underpainting for the finished work, or as the final artwork itself.

Ground: the surface or background onto which an artist paints or draws.

Hand-tint: an early process for adding color to monochrome photographic products by adding pigment in a manner much like painting.

Harmony: cohesiveness achieved by stressing the similarities of separate but related parts.

Haussmannization: the redesign of the city of Paris between 1853 and 1870 that demolished many existing buildings and neighborhoods (often home to working-class citizens) in order to make way for wide new boulevards and other modernizing projects. Named for and overseen by Baron Georges-Eugène Haussmann.

Hierarchical scale: the use of size to denote the relative importance of subjects in an artwork.

Highlight: an area of lightest value in a work.

High relief: a carved panel where the figures project with a great deal of depth from the background.

Hue: (1) the general classification of a color; (2) the distinctive characteristics of a color as seen in the visible spectrum, such as green or red.

Iconography: the traditional or conventional images associated with a specific subject.

Iconology: the study of artistic symbolism, often linked to specific historical contexts and/or particular political, social, and cultural phenomena.

Ideal: more beautiful, harmonious, or perfect than reality.

Idealism: elevating depictions of nature to achieve more beautiful, harmonious, and perfect depictions.

Idealized: represented as perfect in form or character, corresponding to an ideal.

Illuminated manuscript: a hand-lettered text with hand-drawn pictures.

Illumination(s): illustrations and decorations in a manuscript.

Illusionism, illusionistic: the artistic skill or trick of making something look real.

Impasto: paint applied in thick layers.

Implied line: a line not actually drawn, but suggested by elements in the work.

Implied texture: a visual illusion expressing texture.

Incised: cut.

Inlay: a substance embedded in another, contrasting material.

In situ: situated in the original, natural, or existing place or position.

Installation: originally referring to the hanging of pictures and arrangement of objects in an exhibition, installation may also refer to an intentional environment and/or arrangement of objects created as a completed artwork.

Intaglio: any print process in which the inked image is lower than the surface of the printing plate; from the Italian *tagliato a*, "cut into."

Intensity: the relative clarity of color in its purest raw form, demonstrated through luminous or muted variations.

Interpretation: explaining or translating a work of art, using factual research, personal response, or a combination of the two.

In the round: a freestanding sculpted work that can be viewed from all sides.

Kinetic art: art, usually three-dimensional, with moving parts, impelled by wind, personal interaction, or motors.

Kitsch: cultural objects designed to appeal to popular or mass tastes, typically meant to be inoffensive and sometimes perceived as disposable, uninspired, and/or highly commercial forms that stand in contrast to avant-garde experiments.

Line: a mark, or implied mark, between two endpoints.

Linear outline: a line that clearly separates a figure from its surroundings.

Linear perspective: a system using converging imaginary sight lines to create the illusion of depth.

Lithography: a print process done on a flat, unmarred surface, such as a stone, in which the image is created using oil-based ink with resistance from water.

Logo: a graphic image used to identify an idea or entity.

Low relief: a carving in which the design stands out only slightly from the background surface.

Luminosity: a bright, glowing quality.

Manuscript(s): handwritten text(s), as opposed to machine-printed texts.

Mass: a volume that has, or gives the illusion of having, weight, density, and bulk.

Medium (plural: media or mediums): the material on or from which an artist chooses to make a work of art; for example, canvas and oil paint, marble, engraving, video, or architecture.

Mezzotint: an intaglio printmaking process based on roughening the entire printing plate to accept ink; the artist smoothes non-image areas.

Middle ground: the part of a work between the foreground and background.

Mobile: suspended moving sculptures, usually impelled by natural air currents.

Modeling: the representation of three-dimensional objects in two dimensions so that they appear solid.

Monochromatic: having one or more values of one color.

Monolith: a monument or sculpture made from a single piece of stone.

Monumental: having massive or impressive scale.

Mosaic: a picture or pattern created by fixing together small pieces of stone, glass, tile, or similar materials.

Motif: (1) a design or color repeated as a unit in a pattern; (2) a distinctive visual element, the recurrence of which is often characteristic of an artist's work.

Motion: the effect of an activity in which someone or something moves across space and over time; movement.

Mural: a painting executed directly onto a wall.

Narrative: (1) an artwork that tells a story; (2) the story that an artwork expresses.

Naturalism, naturalistic: a very realistic or lifelike style of making images. *See also* realistic.

Negative space: an empty space given shape by elements that surround it.

Neutral: colors (such as blacks, whites, grays, and dull gray-browns) made by mixing complementary hues.

Nonobjective: art that does not depict a recognizable subject.

Nude: an artistic representation of an unclothed human figure, emphasizing the body's form rather than its exposure.

Oil paint: paint made of pigment suspended in an oil-based binder.

One-point perspective: a perspective system with a single vanishing point on the horizon.

Opaque: not transparent; impervious to light.

Organic: having irregular forms and shapes, as though derived from living organisms.

Outline: the outermost line or implied line of an object or figure, by which it is defined or bounded.

Painterly: a loosely executed style in which paint and brushstrokes are evident.

Palette: (1) a smooth slab or board used for mixing paints or cosmetics; (2) the range of colors used by an artist.

Parchment: the skin of animals prepared for use as a material on which to write and/or illustrate.

Pastel: a medium in the form of a stick, consisting of pure powdered pigment.

Patron, patronage: an individual or organization who sponsors the creation of works of art.

Patina: surface color or texture on a metal caused by aging.

Pattern: an arrangement of predictably repeated elements.

Pedestal: a base upon which a statue or column rests.

Performance art: a work involving the human body, usually including the artist, in front of an audience.

Photomontage: (1) a collage composed of cut-and-pasted photographic imagery; (2) a single photographic image that combines separate images (sometimes called a composite image).

Pictorial: communicated or otherwise indicated via a picture or pictures; picture-based.

Picture plane: the surface of a painting or drawing.

Pigment: the colorant in art materials often made from finely ground minerals.

Plane: a flat, two-dimensional surface on which an artist can create an artwork. Planes can also be implied in a composition by areas that face toward, parallel to, or away from a light source.

Plastic, plasticity: referring to materials that are soft and can be manipulated, or to such properties in the materials.

Portrait: an image of a person or animal, usually focusing on the face

Post-and-lintel construction: a construction technique in which a horizontal beam (the lintel) is supported by vertical beams (posts).

Primary colors: three basic colors from which all others are derived.

Print: a picture reproduced on paper, often in multiple copies.

Profile: an object, especially a face or head, represented from the side.

Proportion: the relationship in size between a work's individual parts and/or between one or more parts and the whole.

Provenance: the record of all known previous owners and locations of a work of art.

Realistic: an artistic style that aims to represent appearances as accurately as possible. *See also* naturalism, naturalistic.

Relative placement: the arrangement of shapes or lines to form a visual relationship to one another in a design.

Relief: (1) a raised form on a largely flat background. For example, the design on a coin is "in relief"; (2) a print process in which the inked image is higher than the nonprinting areas; (3) a sculpture that projects from a flat surface.

Repatriation: the return of artifacts, often sacred objects, to their country and/or culture of origin.

Representation, representational: the depiction of recognizable figures and objects/art that depicts figures and objects so that we recognize what is represented.

Rhythm: the regular or ordered repetition of elements in the work.

Saturation (also known as chroma): the degree of purity in a color.

Scale: the size of an object or an artwork relative to another object or artwork, or to a system of measurement.

Sculpture: a three-dimensional artwork, often made by carving stone or wood, or casting metal or plaster.

Secondary color: a color mixed from two primary colors.

Series: a group of related artworks that are created as a set.

Shade: a color darker in value than its purest state.

Shading: the use of graduated light and dark tones to represent a three-dimensional object in two dimensions.

Shape: a two-dimensional area, the boundaries of which are defined by lines or suggested by changes in color or value.

Silhouette: a portrait or figure represented in outline and solidly colored in.

Silkscreen: a method of printmaking using a stencil and paint or ink pushed through a screen.

Site-specific: art created to exist in a specific place. It cannot be moved without drastically altering or destroying the artwork's form.

Sketch: a rough preliminary version of a work or part of a work.

Soft focus: the deliberate blurring of the edges or lack of sharp focus, especially in a still photograph, movie, or video.

Space: the distance between identifiable points or planes.

Stereotypes: oversimplified notions, especially about marginalized groups, that can lead to prejudiced judgments.

Still life: a scene of inanimate objects, such as fruits, flowers, and glassware; sometimes includes motionless animals.

Style: a characteristic way in which an artist or group of artists uses visual language to give a work an identifiable form of visual expression.

Stylized: art that represents objects in an exaggerated way to emphasize certain aspects of the object.

Subject: the person, object, or space depicted in a work of art. *See also* content.

Subordinate, subordination: the opposite of emphasis; it draws our attention away from particular areas of a work.

Subtractive: a sculpting process that involves the methodical removal of material to produce form.

Sunken relief: a carved panel where the figures are cut deeper into the stone than the background.

Superstructure: in Marxist theory, the ideologies, beliefs, norms, relations, and institutions (e.g. political, social, cultural) that reflect the perspective of those at the highest levels of power.

Support: the material on which painting is done.

Symbolism: using images or symbols in an artwork to convey meaning; often obvious when the work was made but requiring research for current viewers to understand.

Symmetry, symmetrical: the correspondence in size, form, and arrangement of items on opposite sides of a plane, line, or point that creates direct visual balance.

Tapestry: a hand-woven fabric—usually silk or wool—with a non-repeating, usually figurative, design woven into it.

Tempera: a fast-drying painting medium made from pigment mixed with water-soluble binder, such as egg yolk.

Temperature: a description of color based on our association with warmth or coolness.

Tertiary colors: colors that can be mixed from a secondary and a primary color.

Texture: the tactile surface quality of a work, for example, fine/coarse, smooth/rough.

Three-dimensional; three-dimensionality: having height, width, and depth.

Time-based art: media that use recording and/or projection technologies to make artworks with durational properties.

Tint: a color lighter in value than its purest state.

Tone: a color that is weaker than its brightest, or most pure, state.

Translucent: semi-transparent.

Transparency: in film and photography, a positive image on film that is visible when light is shone through it.

Trompe l'oeil: from the French, meaning "fool the eye"; an extreme kind of illusion meant to deceive viewers into thinking that depicted objects are real.

Twisted perspective (also known as composite view): a representation of a figure, part in profile and part frontally.

Two-dimensional: having height and width.

Typeface: the particular unified style of a family of typographical characters.

Typography: the art of designing, arranging, and choosing type.

Ukiyo-e: a genre of Japanese art defined by woodblock prints and paintings depicting the everyday lives and interests of the common people. The term literally means "picture of the floating world."

Value: the lightness or darkness of a plane or area.

Vanitas: a genre of Western painting that emphasizes the transient nature of earthly materials and beauty; often seen in still-life painting.

Vault: an arch-like structure supporting a ceiling or roof.

Void: an area in an artwork that seems empty.

Volume: the space filled or enclosed by a three-dimensional figure or object.

Watercolor: transparent paint made from pigment and a binder dissolved in water.

White space: in typography, the empty space around type or other features in a layout.

Woodblock: a relief print process in which the image is carved into a block of wood.

Woodcut: a print created from an incised piece of wood.

Worm's-eye view: a view of an object from below.

Revision Checklists

Introduction

- Have I framed a problem or a question that is worth pursuing?
- Have I provided the necessary context?
- Have I defined important terms?
- Have I placed my thesis within the larger scholarly conversation?
- Have I focused my reader's attention on the argument to come?

Thesis Sentence

- Does my thesis sentence present an arguable claim?
- Is the language of my thesis sentence specific?
- Does the claim I'm making answer the "So what?" question?
- Have I anticipated the counterarguments to that claim?
- Does my thesis sentence provide my readers with a sense of my paper's structure?

Structure and Argument

- Have I composed an argument, or is my paper merely a series of observations?
- Do each of my argument points clearly support my thesis sentence?
- Do I see any holes in my argument?
- Have I dealt fairly and fully with counterarguments?
- Have I created strong transitions from paragraph to paragraph?

Paragraphs and Evidence

- Does each paragraph develop a single argument point?
- Are each of these argument points declared in a well-written topic sentence?
- Have I provided sufficient evidence to support each argument point?
- Have I commented thoughtfully on this evidence?
- Have I correctly attributed the evidence to its original source?

Style

- Do my sentences generally follow the actor/action principle?
- Are my sentences concise?
- Have I structured my sentences so that their emphasis is clear?
- Have I followed the principle of old to new?
- Have I created coherence in my paragraphs by using consistent subject strings?

Conclusion

- Does the conclusion sum up the main point of the paper?
- Is the conclusion appropriate, or does it introduce a completely new idea?
- Does the language resonate, or does it fall flat?
- Have I inflated the language in order to pad a conclusion that is empty and ineffective?
- Does the conclusion leave my readers with something to think about?

Illustration Credits

1 The Metropolitan Museum of Art, New York. Gift of Paul J. Sachs, 1916. 2 The Metropolitan Museum of Art, New York. Ex collection C.C. Wang Family, Gift of the Dillon Fund, 1973. 3 The National Gallery, London. 4 Los Angeles County Museum of Art. Mr. and Mrs. William Preston Harrison Collection. 5 Musée d'Orsay, Paris. 6 The Wallace Collection, London. 7 The Metropolitan Museum of Art, New York. Rogers Fund, 1949. 8 The Metropolitan Museum of Art, New York. The Michael C. Rockefeller Memorial Collection, Purchase, Nelson A. Rockefeller Gift, 1964. 9 The Metropolitan Museum of Art, New York. Harris Brisbane Dick Fund, 1939. 10 Iberfoto/SuperStock and Library at Trinity College, Dublin. 11 Musée d'Orsay, Paris. 12 Howard University Art Gallery, Washington, D.C. 13 Hadnyah/ iStock. 14 The Metropolitan Museum of Art, New York. Gift of Estate of Samuel Isham, 1914.